PAINTING WITH *PASSION*

HOW TO PAINT WHAT YOU FEEL

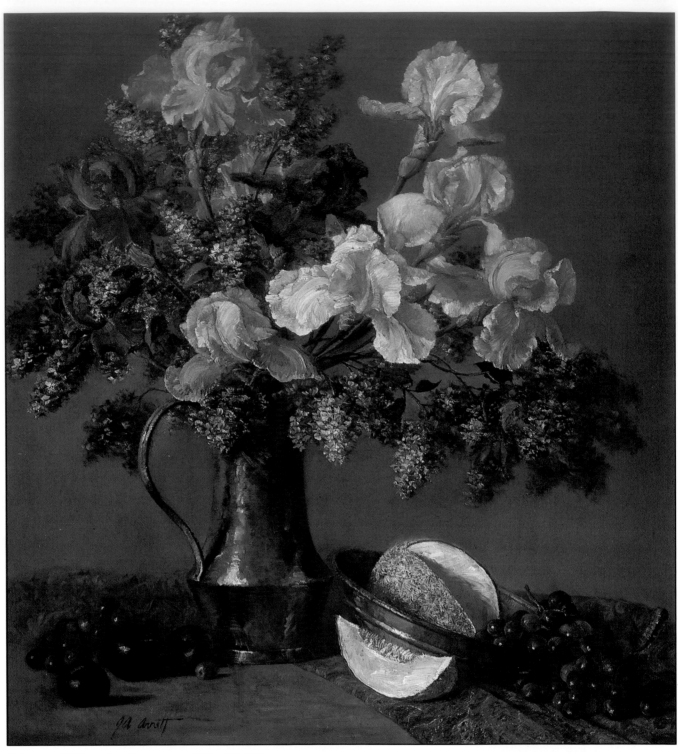

Irises and Lilacs, Joe Anna Arnett, 29″ × 26″, Oil

PAINTING WITH PASSION

HOW TO PAINT WHAT YOU FEEL

CAROLE KATCHEN

NORTH LIGHT BOOKS
CINCINNATI, OHIO

About the Author

Carole Katchen has been a professional artist and writer for thirty years. This is her thirteenth published book. The others published by North Light Books are *Creative Painting With Pastel* and *Dramatize Your Paintings With Tonal Value*. More than one million copies of her books have been sold. Her paintings have been exhibited and have appeared in publications on several continents. She exhibits regularly with Saks Galleries in Denver, Colorado, and Hensley's Gallery of the Southwest in Taos, New Mexico. She lives in Los Angeles where she also writes and produces motion pictures and television for Legacy Productions.

Painting With Passion. Copyright © 1994 by Carole Katchen. Printed and bound in China. All rights reserved. No part of this book may be reproduced in any form or by any electronic or mechanical means including information storage and retrieval systems without permission in writing from the publisher, except by a reviewer, who may quote brief passages in a review. Published by North Light Books, an imprint of F&W Publications, Inc., 1507 Dana Avenue, Cincinnati, Ohio 45207. 1-800-289-0963. First edition.

98 97 96 95 94 5 4 3 2 1

Library of Congress Cataloging-in-Publication Data

Katchen, Carole
 Painting with passion / by Carole Katchen.
 p. cm.
 Includes index.
 ISBN 0-89134-560-4
 1. Painting—Technique. 2. Painters—Psychology. I. Title.
ND1500.K28 1994
751.4—dc20 93-39994
 CIP

Edited by Rachel Wolf and Kathy Kipp
Designed by Clare Finney
Cover design by Clare Finney

METRIC CONVERSION CHART		
TO CONVERT	**TO**	**MULTIPLY BY**
Inches	Centimeters	2.54
Centimeters	Inches	0.4
Feet	Centimeters	30.5
Centimeters	Feet	0.03
Yards	Meters	0.9
Meters	Yards	1.1
Sq. Inches	Sq. Centimeters	6.45
Sq. Centimeters	Sq. Inches	0.16
Sq. Feet	Sq. Meters	0.09
Sq. Meters	Sq. Feet	10.8
Sq. Yards	Sq. Meters	0.8
Sq. Meters	Sq. Yards	1.2
Pounds	Kilograms	0.45
Kilograms	Pounds	2.2
Ounces	Grams	28.4
Grams	Ounces	0.04

*This book is dedicated to my sister Linda
who has always been there for me.*

Thanks to Bobbie Minton and Iris Strom, my partners in Legacy
Productions; to Greg Neff, Colleen Sullivan and LA Art Supply;
to the artists who helped early in my career: Ann Walsh and Jane
Cauhape at West Valley College, Rosalie Tarabini, Pawel and
Irmgard Kontny, Ed Klamm and, as always, the Dawsons; and a
special thanks to the editors and designers at North Light Books
who helped put this book together: Rachel Wolf, Kathy Kipp,
Donna Poehner and Clare Finney.

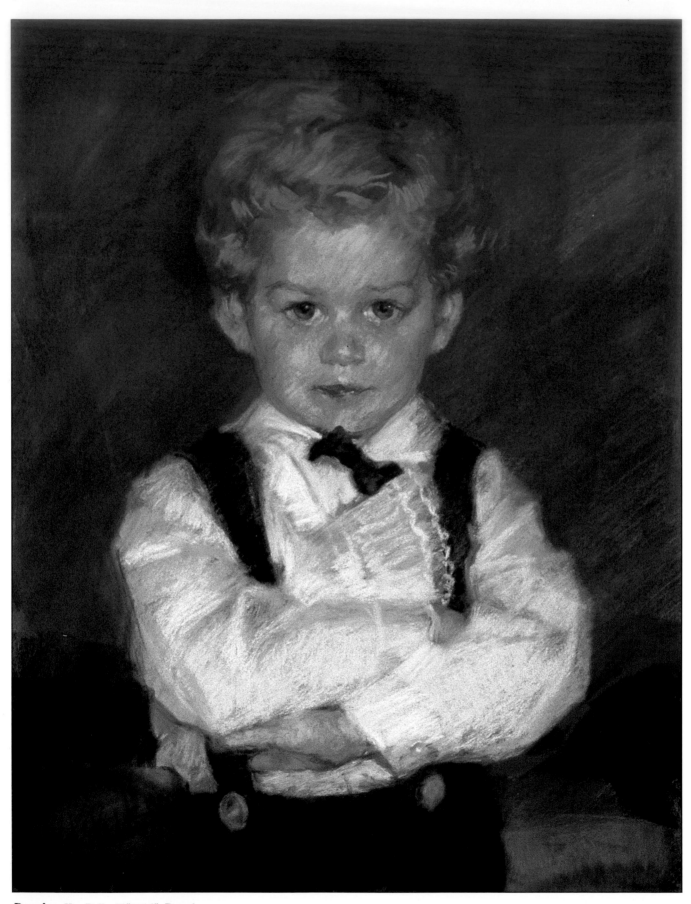

Douglas, Kay Polk, 11″ × 14″, Pastel

Contents

Find the Key to Exciting Paintings: Passion

In Piscataway, New Jersey, David Hunt starts hour 225 of his current oil painting. He knows how he wants it to look, a moody interior with effervescent light, but at this point he's not sure if it's ever going to get there.

In Dallas, Kay Polk patiently explains *again* to a client that, yes, she could paint a portrait of the girl sitting beautifully in a chair, but wouldn't the mother be happier to show the vitality and maybe just a hint of the mischief that makes this little girl special?

In Los Angeles, I look at the pastel I have been painting intently for the last two weeks—the anatomy's good, the color is fine, but there's no expression. I take a paper towel and wipe out the painting, leaving nothing but a ghost image.

As artists, we all understand the expression "the agony and the ecstasy," especially the agony. Day after day, week after week we stand in our studios battling with our materials, our vision, our collectors, our dealers. Why?

In researching this book, I asked fourteen other artists and myself that question. Why are you an artist? Why did you start painting and why are you still painting?

The answer: I love it. There is nothing else I would want to do. It satisfies me. It fulfills me. It brings me great joy.

We artists have been given the gift of passion. We see and feel with an intensity, power and drama that many people never even imagine. We are capable of experiencing and creating great beauty. We can transcend the world of physical structure and verbal limitation. We be-come capable of merging our own identity with everything we see, feel and touch.

However, and this is a big "however," passion also has its dark side.

Each artist in this book is chasing a vision. That vision might be perfect expression of light, harmony of color, communion with the subject. Each successful painting is wonderful because it's a step closer, but it's also a frustration because with each painting we see just how far away that vision still is.

Each of us is Sisyphus pushing the boulder up the hill. We get close to the summit. We think, This time I've done it, this time I've captured my vision. Then we walk back into the studio the next day to look at the newly finished painting and every mistake of light and color and stroke, every shortcoming is painfully, embarrassingly clear. And we find ourselves back at the bottom, starting the push all over again.

On top of the personal frustrations, we must cope with the pain and isolation of being a passionate person in a nonpassionate environment.

We live in a world where passion is suspect. Although most people are secretly hungry for passion in their own lives, they're embarrassed by it, afraid of it. Passion is a force that cannot be controlled. There is no switch to turn it off when it becomes inconvenient. It gets in the way of smoothly running homes, businesses, governments. It breaks down the walls of what's comfortable, what's familiar.

What does all this have to do

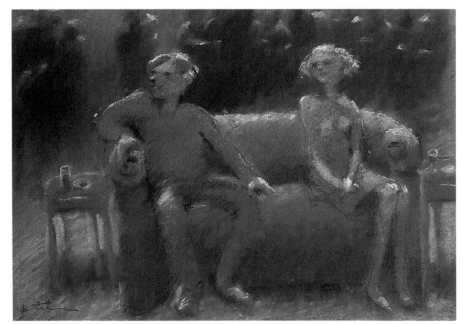

No Relationships, Please, Carole Katchen, 21″ × 29″, Pastel
By watching people I find an unlimited source of subjects for my paintings. I am more concerned with the mood and relationships between people than their actual physical appearance. Here I use the placement of the figures and their body language to tell the story.

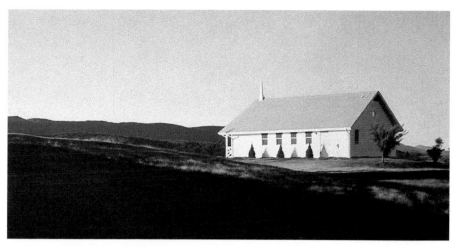

Mountain Church, David Hunt, 20″ × 36″, Oil
This Appalachian church is from his series on spiritualism and religion in America, this one showing "the human presence hard up against full-blown wilderness." Hunt generally spends two hundred to three hundred hours of actual painting time on each of his compositions, so the subject must be something he feels deeply about.

Tres, Kay Polk, 14″ × 11″, Pastel
Although her portraits are commissioned paintings that must please a client, Kay Polk never sacrifices powerful color and rich surface texture. She believes a good portrait must be a good painting as well.

with one artist alone in his or her studio? Well, that's just it. You are alone in your studio. You are the one, the only one, trying to make that particular vision real. You are the one working toward the mastery of your materials. No matter how many friends, family and collectors you have cheering you on, in the world at large you are an isolated and somewhat fear-inspiring being.

It may be gratifying to be led by a vision, but you are alone and there is part of you that wants to fit in, that wants to be liked, that wants to have people like your paintings. That very human part of you is always there, trying to control, to mask, to minimize the passion. This is the great paradox of the artist — I am driven by my passion, but I'm also trying to run away from it.

You might rip up a watercolor or two, lock the studio door, and go away for a few days, but you come back. The passion brings you back. The thrill of capturing the glint of morning sunlight on a mountain stream, that delicate little curve along the model's jawbone, the perfect blue to make the orange poppies vibrate.

David Hunt says, "Each painting is almost like a marriage. When you first fall in love, you're suddenly infatuated and you're nuts. That's how I feel when I'm starting an image. I'm really excited — this time it's going to be great! But you don't know what you're getting into. When I'm two hundred hours into the painting, I'm no longer infatuated. It's grown into a different kind of love. We might be fighting and disagreeing, but still I'm trusting that it's going to work out."

Just like a marriage, it is the everyday relationship with painting that keeps us walking back into the studio. The satisfactory paintings, the successful shows, the positive reviews, the major sales — those are all great. But what makes us walk

through the door every day is the process of painting, the day-by-day adventure of seeking the perfect color, attempting the perfect stroke.

That's what this book is about, finding passion in your day-by-day experience of painting. I have chosen a wonderful group of artists to share with you the passion that they have discovered in their own work. They speak here not only of the "grand passion" of painting as a life-style, but also the smaller passions for subject and color and gesture and materials.

Of the fifteen artists included in this book, almost every one began drawing and painting as a small child. Some had serious art training from the time they were in elementary school; others didn't begin their formal involvement with art until they were much older. Martha Saudek didn't even consider being an artist until she had retired from her career as a teacher and school administrator.

However, each one, with no exceptions, says that art fills a vital space in their life. When they are forced by circumstances not to enter their studios for a time, they feel disconnected with their inner selves, their spiritual selves.

It is possible to live one's life joyously without art. It is possible to enjoy the simple activities that we all share as human beings— eating the perfect piece of apple pie, paying off the mortgage, wiping away tears at a movie, playing softball with the neighbors, celebrating anniversaries and your children's birthdays. Life is always a gift.

But for the artist, life is more. It is a *glorious* adventure. Every moment is a treat for the eye. We are touched by the passion for color; a magenta sunset or a cerulean blue flower can take your breath away. We are gifted with reverence for light, watching with fascination as morning sunlight drifts through the

The Way 5, Alberta Cifolelli, 48″ × 54″, Oil
Cifolelli's expressive paintings are of subjects she invents. The flowers and other landscape elements are only a vehicle for the dynamic color and strokes of her painting.

Rock View at Little Sur, Gil Dellinger, 32″ × 42″, Pastel
Dellinger's landscapes are not so much concerned with the trees and rocks of a particular scene as with the light moving across those elements. He spends hours in each location, watching the light and shadows change. Each painting captures a moment of light.

kitchen window. And perhaps most miraculous, we are gifted with the need to celebrate our passion with marks on paper or canvas.

Passion shows itself differently to every artist. Phil Salvato mixes his own oil paints. Gil Dellinger sits for hours watching the afternoon shadows creep across a hillside. Joe Anna Arnett grows the irises for her florals, while Alberta Cifolelli never even looks at a flower when she is painting hers.

Each one is painting with passion, following his or her own passion. In this book they show the images they love and describe the process they use to create those images. They intimately share what passion means to them.

For the reader this is an opportunity to experience other artists' passion, but even more important, it is a chance for you to define your own. What is it that is satisfying to you as an artist? What is challenging? What is frustrating? By sharing these examples, anecdotes and exercises you too can explore your gift as an artist and paint with passion.

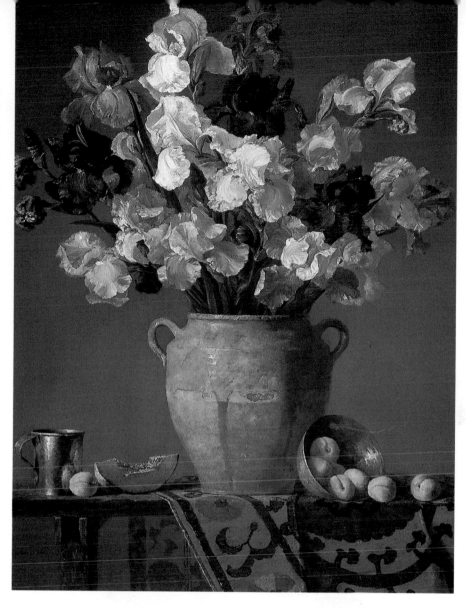

Dobbs Irises
Joe Anna Arnett, 36″ × 30″, Oil
For Arnett, flowers are not a sweet, delicate subject matter, but rather a strong living presence with rich color and dynamic shapes. She grows irises in her backyard so that she will have a wide selection.

The Old Picnic Grove
Philip Salvato, 18″ × 24″, Oil
Salvato's oil paintings have tactile as well as visual appeal. Notice the sculptural feel of thick strokes built up on the canvas. He mixes his own oil paints so that he will have more control.

ONE

STARTING WITH THE SUBJECT

What people paint is as varied as *how* people paint. Figures, buildings, flowers, animals, hillsides, water, clouds—the list is endless. I have heard beginning artists ask, "What is the best subject to paint?" as if some subjects are better than others, as if some subjects are right and others are wrong. The truth is that any subject is "right" if that is what you passionately want to paint.

Some artists know from the beginning what subject is best for them. I never had any doubt that I should paint people. I have painted other subjects, but I always go back to the human figure because that is what interests me most. I have learned to paint interiors and flowers and various other objects, but just so that I can provide a setting for my figures.

For some artists it takes years of painting a variety of subjects before one emerges as their primary interest. Gil Dellinger, for example, painted figures and historical scenes before he discovered that he loves landscapes.

That beginning artist who is looking for the "right" subject need not be concerned. Your likes and dislikes, your interests and apathies emerge naturally as you continue to paint. However, it is crucial to keep yourself open to new ideas and images.

When you are passionately committed to a particular subject, that is what comes first in your art training as well as the execution of each painting. You know *what* you want to paint; everything after that is just figuring out how to do it.

I believe that subject came first in the historical development of art as well. There was an image someone wanted to record and they learned whatever skills they needed in order to make that happen. Certainly the cave artists of Lascaux did not go to an academy to learn the right way to paint bison on the walls. They just painted the images they cared about with whatever materials and techniques were available to them.

I am not saying that technique is unimportant, far from it. I believe that, as an artist, you should acquire more technical knowledge than you will ever use. That gives you greater freedom and facility in conveying your subject. However, when you know what you love to paint and you let that passion propel your art, it gives you greater power in developing and using whatever techniques you choose.

One of the biggest traps for professional artists is painting "what sells." How do you know what sells? You look at your own past sales, you listen to what your dealer tells you, you notice what is being shown in the galleries or you believe the local mythology.

When I lived in Denver "everyone knew" (the local mythology) that the only things that sold were landscapes and Indians. Believe me, I would have painted landscapes and Western scenes myself if I could have. But, as much as I appreciate another artist's ability to capture the late afternoon shadows creeping across the meadow, that's not what I see. As I walk through my everyday life, I may notice a garden or sunset in passing, but what I really see are the people who inhabit the world with me.

For fifteen years I made a living from my art in Denver, painting "what did not sell." It wasn't always easy. One year my friend Ed sold his camera so we could afford to buy frames for one of my exhibits. However, collectors were eventually moved by my passion and I was able to paint and grow and travel around the world.

I am not exceptional. I don't know of any successful artist who has been able to navigate his or her career without sacrifices of some kind. Artists survive poverty. Artists survive just about anything but giving up that primary passion that drives them.

Another consideration that can inhibit artists from painting what they care about is what gets into shows. What are the judges looking for? Even more than wanting to win prizes, I think we are driven by wanting to avoid rejection. What you are painting is what you love — how devastating to have someone reject what you love. Well, I can't speak for other judges, but I can tell you what subjects I look for when I'm judging a show — any subject that the artist is totally committed to.

Like poverty, rejection is another thing that artists learn to survive. The strength for transcending rejection comes from knowing that you are painting what you care about, that you are painting as well as you can and that you are going to get better just because you continue. What gives you the impetus to continue? Painting the subject that you love.

It is only when you are passionate about a subject that you will take the time to see the subtle nuances, to explore and challenge and expand the image in front of you. It is like the difference between looking at any face and looking at the face of the person you love. Only with your loved one do you notice the delicate shadings of blue in the eye, the irregular curve of the eyebrow, the slight indentation of a dimple just before he smiles. When you paint the subject you are passionate about, you see that subject with the laser-sharp vision of a lover.

How do you know which subjects are the ones that you are most passionate about? For some of us it is obvious; there really is nothing else that we would consider painting. For others it takes a bit of checking. Some questions to ask yourself:
What subjects do I most like to look at in other people's paintings?
What subjects am I willing to spend the longest time working on?
What subjects make me feel happiest when I'm painting them?
What subjects do I see most clearly?

There are many great artists who are not driven by subject matter. Their passion is for color or design or even the materials that they use to make images. They can approach any subject with equal commitment and an exhibition of their work contains a vast array of subjects.

For the rest, however, it is valuable to take the time to think about what you paint. Know what subjects challenge and inspire you. Before you begin a new painting, carefully consider whether this specific subject is one that excites you.

Rome Hardware, Philip Salvato, 21″ × 48″, Oil

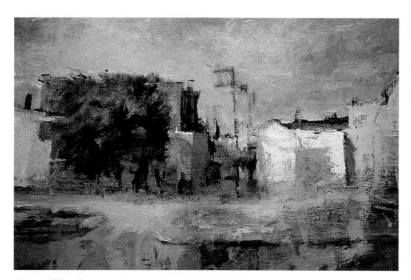

Rome Hardware, Philip Salvato, 24″ × 36″, Oil

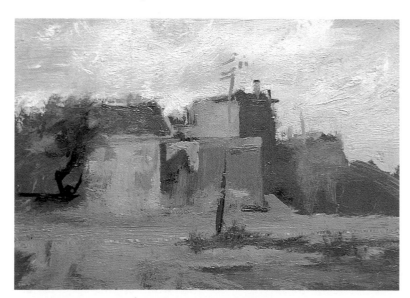

Rome Hardware, Philip Salvato, 10″ × 14″, Oil Sketch

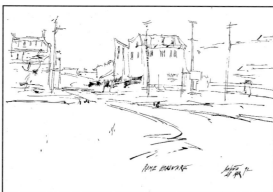

Rome Hardware, Philip Salvato, Pen and Ink

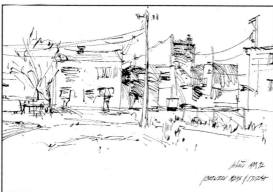

Rome Hardware, Philip Salvato, Pen and Ink
Like many artists who are committed to subject matter, Salvato enjoys developing one subject in many different forms. He begins with simple pen-and-ink drawings, proceeds to oil sketches, and then completes several finished oil paintings of the same subject. This allows him to explore both the subject and his technique for portraying it.

Our Lady of the Harbor
John Dobbs, 12½″ × 9″, Oil
John Dobbs chooses subjects that appeal to the mind as well as the eye. His paintings often question the state of humankind's existence in an urban world.

Late Afternoon
Donna Levinstone, 24″ × 36″, Pastel
Levinstone uses landscapes to convey her experience of light. However, her paintings are not of any specific landscape, but rather an amalgam of many Atlantic scenes during various times of day.

Whether you spend months on a single painting or complete a work in a few hours, the commitment you feel to the subject will have a profound effect on the results.

When I absolutely love a subject I am working on, I am not willing to compromise the results. I won't skip over the hard parts or rush to finish it just so I can start something new. Embarrassing as it is to admit it, I have done those things in the past when I wasn't totally committed to my subject. The hands don't look exactly right? Stick them in the shadow. The color isn't quite balanced? Forget it; you can do better in the next one. That isn't possible when I am committed to the subject. It's like being with someone you love—your second best just isn't good enough.

Learn to recognize your own passion for the subject and use that passion to give your day more energy, your vision more incisiveness and your life as an artist more satisfaction.

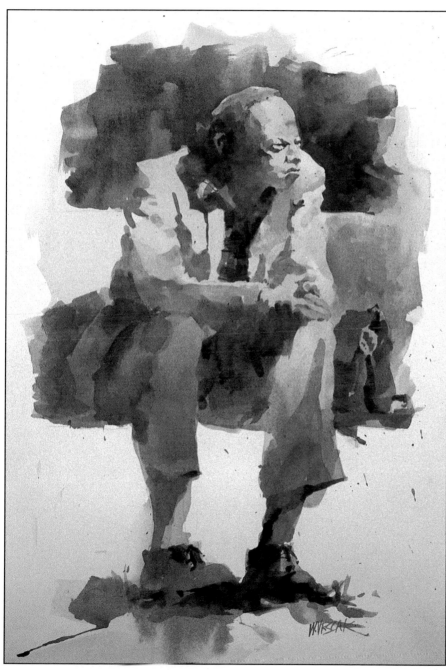

Plaid Shirt, William Vrscak, 15″ × 22″, Watercolor
When Vrscak worked in downtown Pittsburgh, he spent lunch hours on the square drawing the folks who wandered through the area. He filled numerous sketchbooks with these drawings and used many of them as studies for watercolors.

Squirtin' Poppa
Kay Polk, 14″ × 18″, Pastel
Polk loves to paint children in sunlight. She
says the bright sun brings out wonderful
colors in areas of reflected light, as you can
see in the red, yellow, blue, purple and
green shadows on the child. In the details
you can see how she builds the image with
individual strokes of strong color.

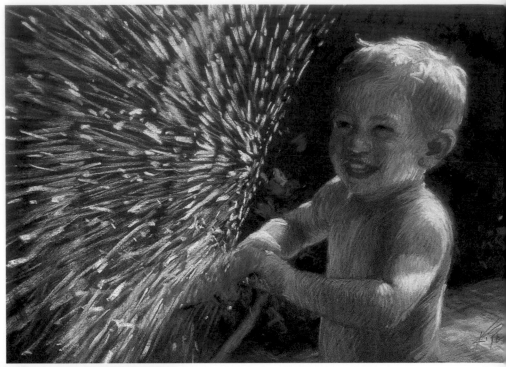

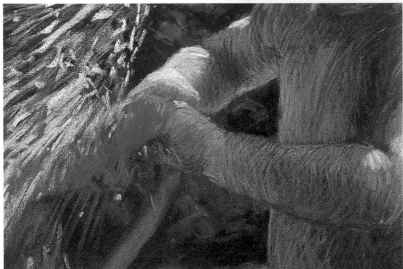

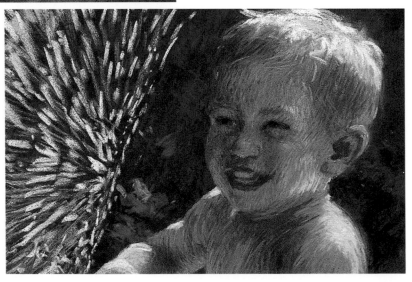

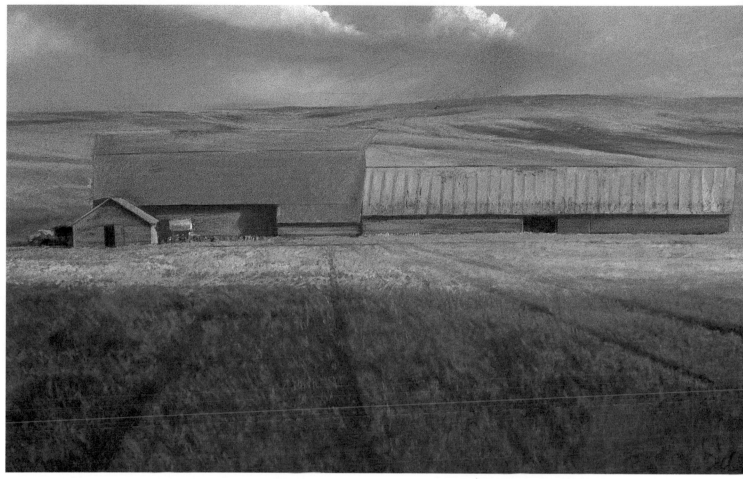

Rain Above Tracy Kaiser
Gil Dellinger, 32″ × 48″, Pastel
The elements of this painting are a barn, fields and sky, but the subject is actually a moment of light falling across the farmlands.

Picking a Subject

What do you *really* want to paint? Many times we think we are painting what we want, but actually we are painting what's convenient or popular or expected. Complete these sentences and see what you discover about your choice of subjects:

- If I did not have to worry about selling my art, I would paint . . .
- If I had plenty of time, I would paint . . .
- If I had only one day left to paint, I would paint . . .
- If I could paint anything well, I would paint . . .
- If no one were watching, I would paint . . .
- If everyone in the world were watching, I would paint . . .
- If I never had to enter another show, I would paint . . .
- If I were famous, I would paint . . .

Demonstration

Nursing

Henry Casselli, 24″ × 18″, Watercolor Study
Although many of Casselli's paintings are
of bold, masculine images, he is not afraid
to paint more tender subjects as well. This
painting of his sister-in-law and her child
was done as an antidote to the negative
feelings he brought back from his experi-
ence as a marine in Vietnam. This is one
of several preliminary drawings and water-
color sketches.

Step 1: He begins by aggressively placing
his darkest values. The contrast of extreme
darks will keep the painting from looking
too soft and sentimental. He works down
and out from woman's head, establishing
three-dimensional form and painting in
many of the details as he goes.

Step 2: Once the figures are in place, he
starts to develop the design of the negative
space.

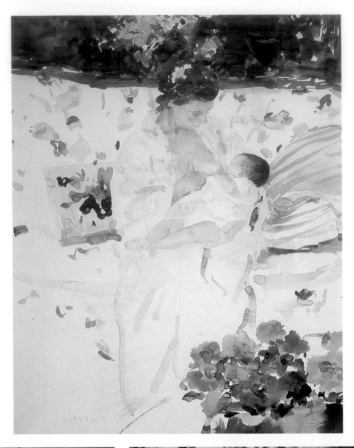

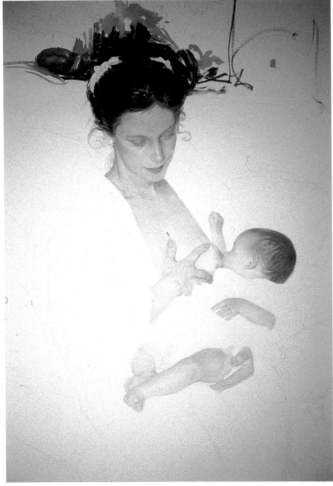

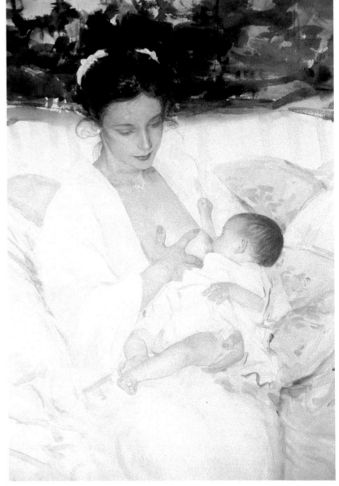

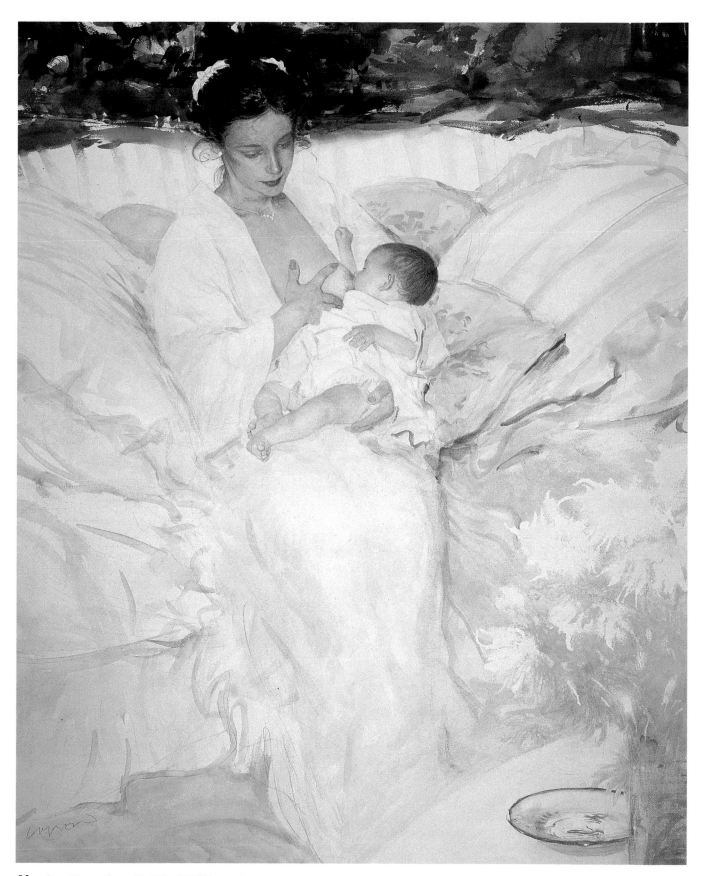

Nursing, Henry Casselli, 52″ × 33″, Watercolor

Notice the strong diagonal thrust of the painting from upper left. The primary focal point is the woman's head, reinforced by the intense colors of the upper background. The eye moves diagonally down to the baby and then on to the dish in the lower right. Casselli created the white flowers in the lower right by sanding and scraping the painted surface of the paper.

JOE ANNA ARNETT

Painting From Life

Iremember as a very young child seeing beauty in the world of still life. There is a wonderful peace in the simple objects of life." Thus, Joe Anna Arnett explains her attraction to the subject of still lifes.

She says there is a beautiful universality of utilitarian forms. The shapes of pots and baskets unite the present world with past, confirming our heritage as human beings.

Another reason still lifes are so attractive is the artist's ability to totally control and manipulate the subject. Put a vase, a pot and a basket on a table and they will stay there for days without moving, without complaining and without having to take a break to stretch or get a drink of water. Arrange them under a north light, as Arnett does in her studio, and you have the freedom to explore their nuances of shape, color and texture at your leisure.

Each painting that Arnett undertakes has a specific problem for her to solve—balancing an odd assortment of forms, establishing depth with similarly colored background and foreground, or some other compositional puzzle. "It's not difficult to come up with a good solution: It's difficult to come up with a good problem," she says. Working with still lifes gives her the freedom to dream up new and interesting problems.

Fruits, vegetables and flowers are a bit more complicated because they are not permanent. In time these living things wilt or fade, but for Arnett that time pressure simply adds a touch of drama to the act of painting.

She lives in Santa Fe cultivating a large flower garden to paint from and she finds the flowers a never-ending challenge. She explains, "You could spend a lifetime painting irises and never exhaust the color world. And the forms . . . How do you paint the same form season after season and still come up with something new? The flowers themselves tell you different and unusual things to do. If I can't think of a subject, I go out and walk around the garden."

Arnett paints in a traditional manner. She paints with oil on Utrecht linen that she primes herself with two coats of rabbitskin glue and one coat of lead white. She uses very long filbert brushes that give her a lot of play, "one size larger than I think I'll need."

She begins her paintings by blocking in the forms. She explains, "It's more important to get how the flower feels and the form of it than every nook and cranny. The stripes are only details. You can paint those on anytime."

She masses in the shapes and values with loose strokes of thin paint. Gradually she adds color, refines the values, and thickens the application of paint for the final strokes of impasto highlights.

She continues to hone her drawing skills by bringing a human model into the studio once a week. She says, "If you can articulate a deltoid muscle, an apple is downstream from there."

She moved to New Mexico to be in an environment that would support her art. It was when she and her husband bought a house and began to landscape it that she discovered flowers. For her they are not delicate and sweet, but a powerful form of color. She says each flower is a universe for exploration.

Even though the flowers change so quickly, Arnett does not work from photos. She explains, "A photo is an emotionless, flat plane. You can develop a rapport with a live flower. You can hold it, look at it, study where the petals come from and what is the total shape. I tell my students, if you can't afford to go to the florist and buy a whole bunch of flowers, buy just one. It will teach you to paint."

Arnett wants her paintings to be life-affirming, more alive and vibrant than the flowers themselves so that the viewer will never look at that subject in the same way again.

About being an artist, she says, "I am so grateful. When I get up in the morning, the thing I *must* do to make the mortgage payments is the thing I *choose* to do. Every day I am that little kid again who made something and rushed home to show it to mother."

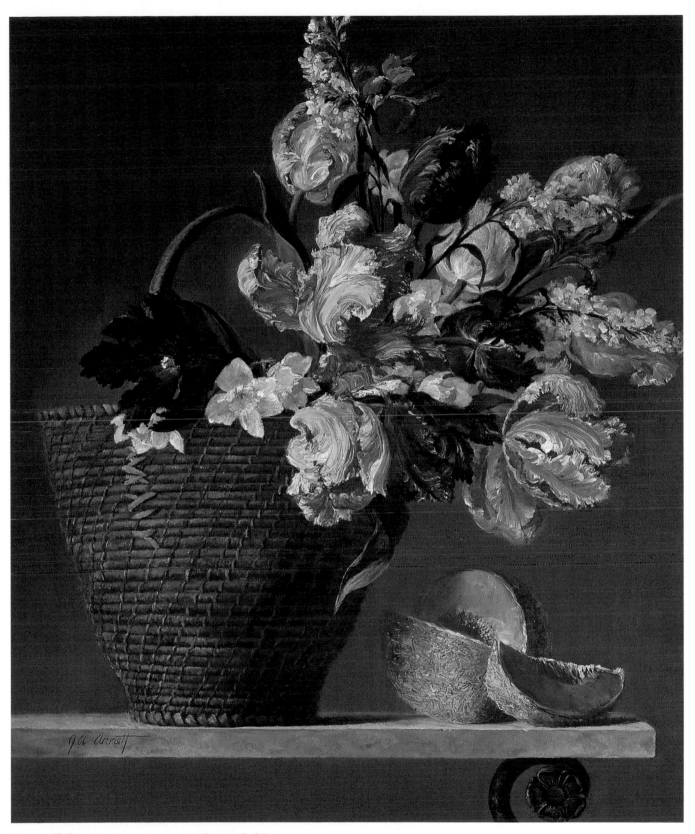

Parrot Tulips, Joe Anna Arnett, 25½″ × 21¼″, Oil
Arnett says, "Parrot tulips are among my favorite flowers. They lend themselves well to rich, heavy impastos and because they change and move, they encourage you to work quickly. I like that. A flower that isn't labored over usually looks fresh and alive."

Demonstration: A Passion for Still Life

In this photo you see the setup Joe Anna Arnett created for her painting: fresh lilacs, fruit, a basket and bowl and a tapestry for the background. She always paints from live subjects rather than photos, which is why she prefers still lifes.

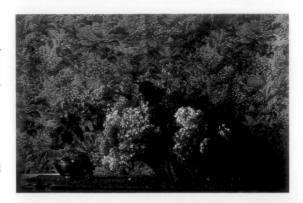

Step 1: In the first stage she masses in all the large shapes with thin washes of oil. Before considering detail, she locates the abstract areas of color and value, creating the foundation of her composition.

She defines the light and dark areas and starts to show the character of the flowers. She uses looser strokes for the background to make it recede.

Step 2: She develops the lilacs quickly, anxious to capture their shape and color before they wilt. Notice that she does not paint every single petal, but uses only enough strokes to give the feel of the flowers.

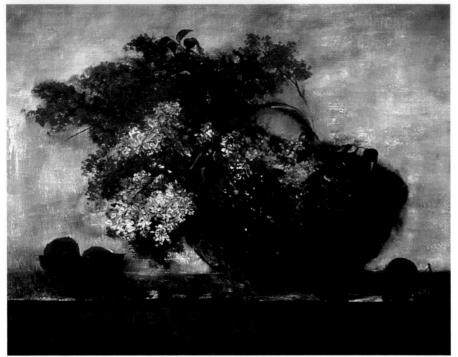

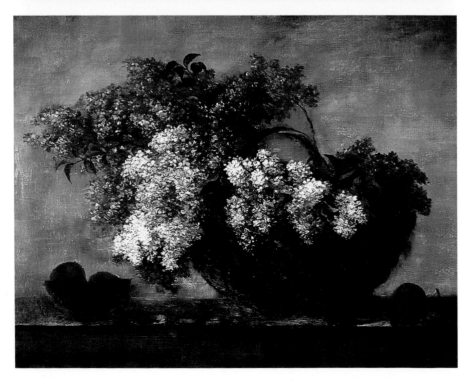

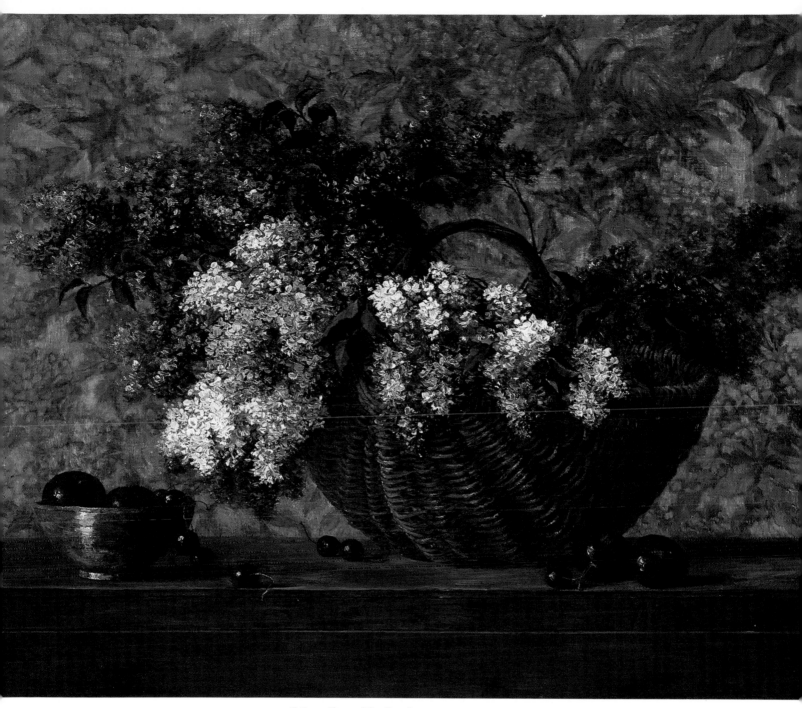

Lilacs From My Garden, Joe Anna Arnett, 23¾″ × 28¾″, Oil
In each painting Arnett creates a problem to solve. She says, "The challenge here was distinguishing the planes of foreground and background while using the same basic pigments to create both. The lilacs in the foreground are done with crisp edges, pushed contrasts and heavy impasto. As the lilacs recede into the background, they become less distinct, have less contrast and simply less paint. The background is done with soft edges, minimal contrasts and very thin paint."

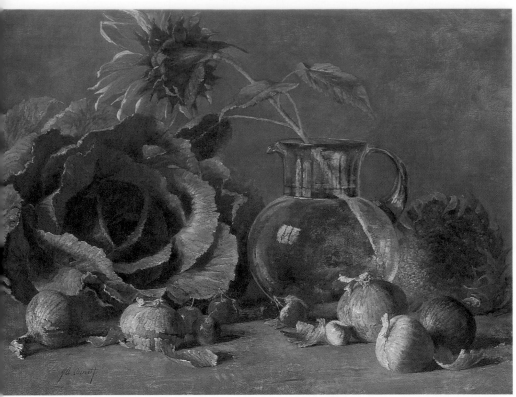

Cabbage With Sunflower and Crabapple
Joe Anna Arnett, 18" × 24", Oil
Arnett does not choose just any objects for her still lifes; each one is carefully chosen for color, shape and texture. She grows purple and green cabbages in her garden because she likes to paint them with all the extra leaves before they have been washed and trimmed. The shapes of the cabbage leaves are repeated in the onion skins in the foreground.

Harvest Bowl
Joe Anna Arnett, 8" × 18", Oil
The artist says, "This beautiful Wedgewood bowl was loaned to me by a client who asked me to paint it for her. I looked at it for months before I decided how to do the painting. The bowl is more formal than the things I usually choose to paint. The extremely horizontal format and the very informal onions solved the problem for me. The dried onion tops and bits of onion skin also helped by providing devices to direct the eye back to the bowl."

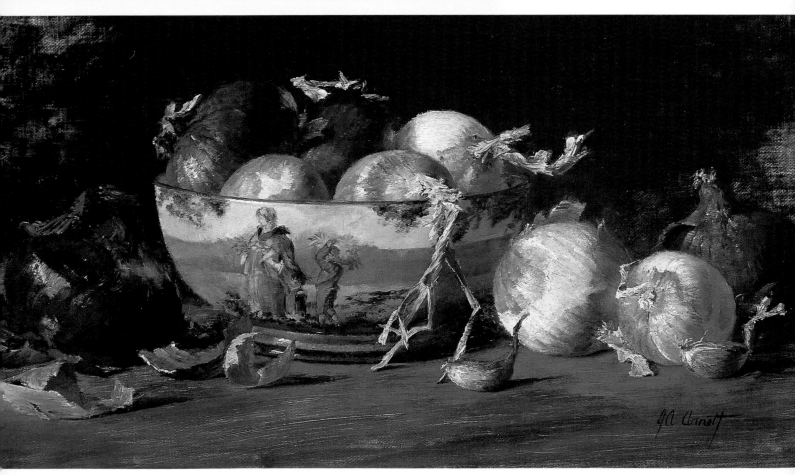

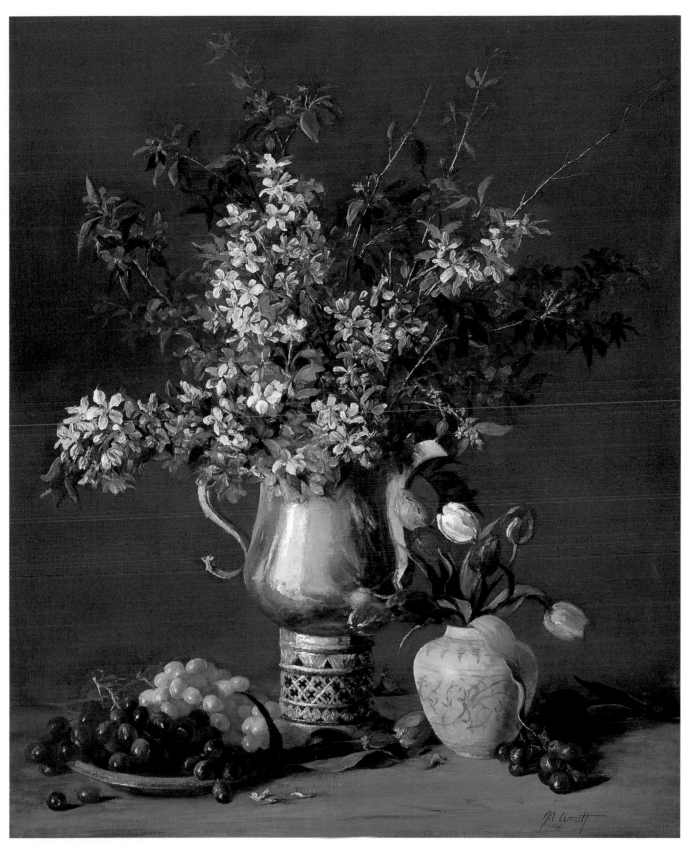

Crabapple Blossoms in Samovar, Joe Anna Arnett, 30″ × 24″, Oil
When painting flowers or branches of blossoms, it is important to look at the total shape
of the flowers rather than the individual blossoms. Notice that more light falls on some
segments of the flower group, so some of the blossoms will be painted more brightly than
others.

What's in a Look?

I am one of the artists in this book who had no traditional art education. My family never went to museums, we had few pictures on the walls and my early taste in art was guided by comic books and the Sunday funnies. What I did have was a fascination for people. I loved watching them and making up stories about them. My drawing was to illustrate those stories.

At nineteen, I illustrated my first children's book. The drawings weren't elegant—kids with long skinny legs, knobby knees and big toes. Definitely not High Art. But they created the characters I loved and the book sold 700,000 copies. I am still drawing those same characters for television animation.

Over the years I took an occasional art class and I spent hours and hours drawing live models. For years I attended figure drawing sessions four or five times weekly. In the early 1970s I met artist Pawel Kontny, who helped me train my eye and make my first professional gallery connections.

Since then my greatest source of art education has been interviewing other artists for books and magazine articles. My writing assignments force me to learn how other artists think and see; every one teaches me something about light, color, composition or paint application.

During my career I have painted an amazing variety of human subjects—all-star wrestlers, transvestites and punk rockers, mimes and dancers, Amazonian Indians, symphonic musicians. I'll paint anyone who has an interesting look—not their facial features or costume so much as their emotional expression.

I look for a strong emotion, an intriguing relationship between figures or a dramatic situation. It shows itself not so much in the facial expression as in the body language. Are they leaning toward each other or twisting away? Are the hands relaxed or clenched or hiding the face? Is the figure hiding in the shadows or preening in the sunlight?

I live in Los Angeles now, a wonderful place to watch people. Whenever I see an intriguing subject in a cafe, at a concert, even standing on a street corner, I make a sketch. I record as much information as I can quickly, concentrating first on the gesture of the figure. Sometimes it's as little as a cheek line and arched neck; sometimes it's a group of figures and their complete environment.

Students often tell me they're embarrassed to draw in public. The trick is to concentrate so intently on your subject that you don't have time to be concerned with anything else. I admit I was shy at first, concerned that the drawing would be bad and people would laugh at me, but I continued anyway. After having dozens of villagers in markets in South America and Africa watch me draw, there isn't much that unsettles me anymore.

Once I record the basic information, I complete the image in my studio. I rarely worry about physical likeness. I change any aspect of the subject to better express the mood or relationship. I add or delete figures, move them indoors or outdoors, change a redhead to a brunette or a black woman to an Asian.

At times I work directly from a live model. At first, I worked with any available model, but now I'm much more particular. Physical appearance is not terribly important, though I do enjoy strong facial features. My primary concern is the energy and mood the subject projects. A bored, low-energy model results in a boring, low-energy painting.

My medium of choice is soft pastel on a textured paper, either Canson or Fabriano Murillo. I like a very toothy paper because it holds several layers of pastel; I can build up more interesting colors and textures. My favorite pastels are Schmincke and Sennelier. Schmincke sticks of color are wonderfully soft with intense hues, especially in the lighter values. Sennelier makes great dark colors, but you must test each stick; sometimes they are too hard to layer well on paper.

I avoid the popular hard pastels. The pigment is difficult to move around the paper surface and many colors are not color-fast. The reds seem to fade quickly in sunlight.

I start the painting with a simple contour drawing. Then I block in the basic figures and values before I build up the finished image. Often I wipe out the first layers of pastel, leaving just a ghost image to work from. I may paint and wipe out several times before the figures and composition are right. After that I use a variety of techniques to build up my final color—hatching, crosshatching, blending, erasing.

You must be fearless with pastel or your results can look stiff and lifeless. I remind myself that nothing in the painting is precious. When I try to preserve a particular line or color, the whole painting becomes stiff. When that happens, even after weeks of work, I take a paper towel or the palm of my hand and wipe the whole thing out. This doesn't eliminate all the color from my surface; it simply redistributes it, creating a softer layer of color and less specific underpainting for me to work over. (I always warn students who are worried about possible toxic effects of pastels not to use bare hands to blend their colors or to use the protective cream Artguard.)

Another technique I use when I want to change the direction of a painting is to spray it with fixative. I use several thin coats, enough to give a workable surface, but not enough to make a thick, plastic coating. I also use fixative to set colors and values within the course of the painting and to preserve the final image. I am careful to cover my nose and mouth and use spray fixative only in well-ventilated situations.

Rarely do I know at the beginning what the finished painting will look like. I know the subject I want to convey, but how it will be expressed finally is always a mystery. I look on each painting as an exploration, an opportunity to learn more about my art.

After thirty years as a professional artist, I am still driven by my passion for the same subject—the way people look, the way they posture and position themselves in relationship to others. My eye has become more refined and over the years I have acquired the technical skills to create more sophisticated images, but the basic passion has never changed.

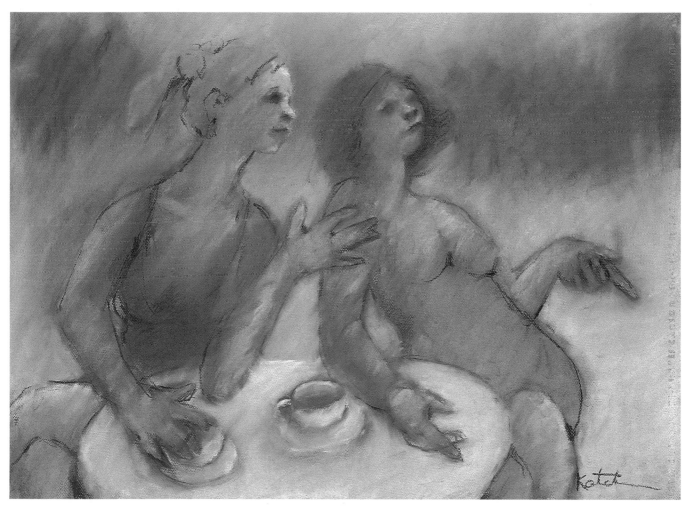

The Starlets Plan Revenge, Carole Katchen, 21″ × 29″, Pastel
From the beginning of this painting I am most concerned about the gesture of the two women, which shows their relationship and their personalities. They are leaning toward each other, definitely friends or allies. Their hands and direction of their faces show they're involved in an animated discussion about someone or something out of our view. I like my paintings to start a story that the viewer can finish.

Demonstration: A Passion for Telling the Story

Step 1: I began this painting with a black-and-white study drawn from the model. I usually paint from studies, almost never from photos. I like the freedom to improvise when I'm working from a simple drawing rather than a live model or photo. I often use actual props to create the background; here I worked from a vase of live flowers.

Step 2: I drew the figure and filled in the background with strokes of blue pastel. With a paper towel I blended the background; then using pastel that had accumulated on the towel, I marked the darker value areas on the figure. I generally work on toned pastel paper; this was a sheet of gray Canson Mi-teintes.

Step 3: I hatched in the lighter and darker colors in the figure with loose strokes that I would blend later with a paper towel or my hand. I was worried about the flowers wilting, so I developed that area of the painting more quickly. Again I was most concerned with the light and dark areas.

Step 4: I continued to develop the colors and values, adding strokes of color, blending and adding more strokes. However, I was already beginning to feel there was something wrong with the painting.

Step 5: I worked on the painting for some time before I realized that the anatomy was off and, even worse, I hated the pose. It was too boring.

Step 6: I wiped out the entire figure with a paper towel and redrew it, giving the figure a much more dynamic gesture.

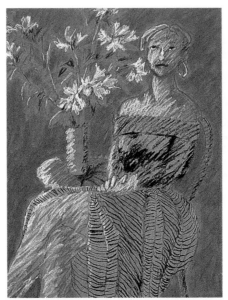
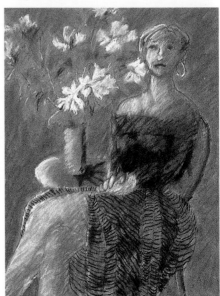
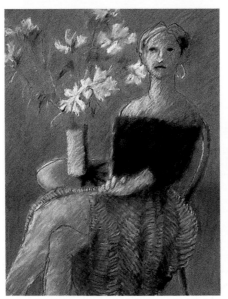

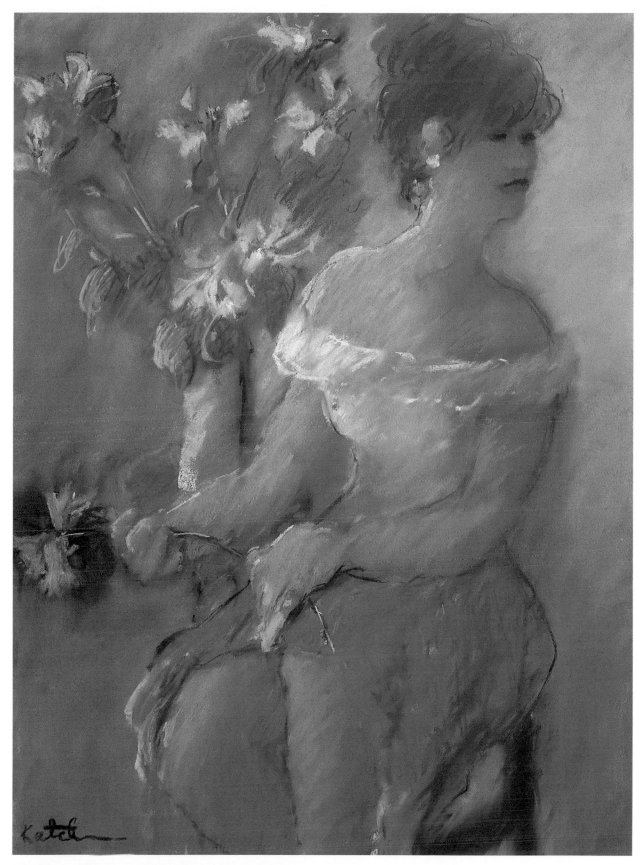

Hot House Flower, Carole Katchen, 29″ × 21″, Pastel

In the past I hated to wipe out a painting or part of a painting. Now I enjoy it. I am left with a ghost image of what went before; so I can work from what I have already learned about the painting. However, I no longer have to worry about ruining it. The worst has happened. Now I can be totally free to experiment and invent.

Sunday Afternoon Concert
Carole Katchen, 25″ × 19″, Pastel
The diagonal thrust of the figure and flute add movement to this composition. The soft, blended color expresses the gentleness of the music.

Texas Roses
Carole Katchen, 27″ × 39″, Pastel
In a painting like this where the figures are practically silhouettes, the body language is more important than facial expression or anatomy for telling the story. The relationship between the women is established with placement, posture, direction of their gazes, and use of their hands.

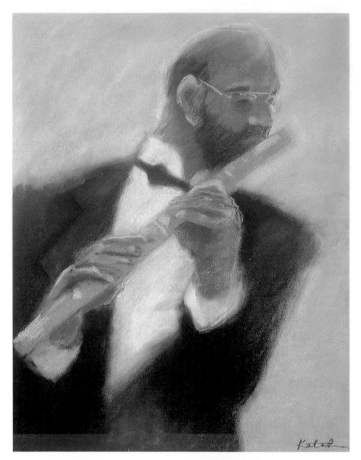

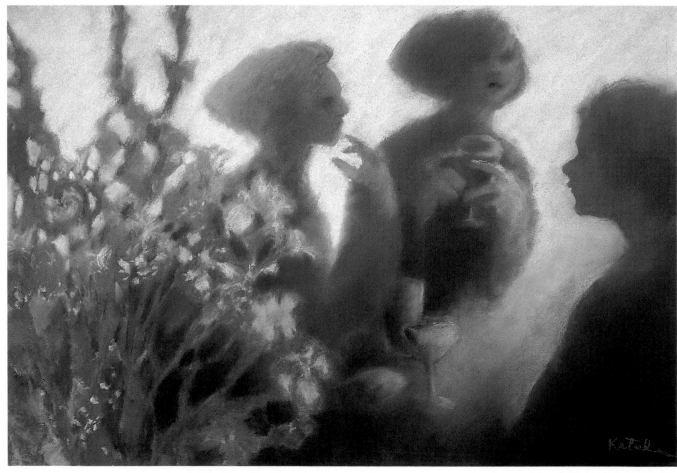

Confessions in the Deli
Carole Katchen, 27″ × 39″, Pastel
This piece was a compositional puzzle. The drama is contained in the relationship between the large figures. Although they are separated by the width of the format, they are kept together in the forward plane with the use of the brightest colors. The background figures divide up the negative space, but don't intrude because they are smaller and painted in medium, grayed values.

African Smile
Carole Katchen, 29″ × 21″, Pastel
The figure was based on a model I used in a workshop. Her costume and background were remembered from time I spent in West Africa. I created a sunset backlighting the scene to give it more dramatic impact.

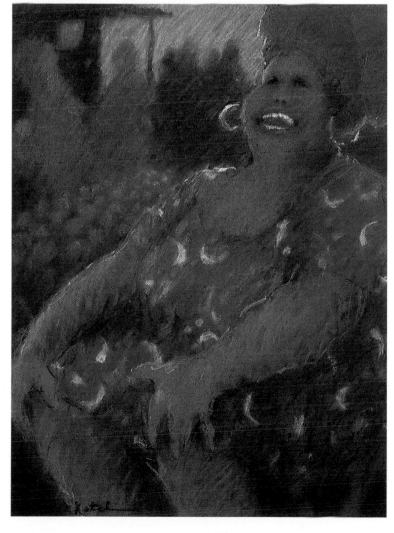

Long-Term Relationships

David Hunt has spent as many as three hundred hours on a painting. He says that when you're going to make that kind of investment in a painting, you have to be sure it's a subject you love. According to Hunt, he doesn't choose the images; they choose him, sometimes "rattling around" in his head for years before he puts them on canvas.

David Hunt's oils are of realistic scenes, landscapes and interiors. He pays scrupulous attention to form, light and detail, but the image itself is less important to him than the emotion it conveys. Although the images look like they are true to the existing world, many elements in the paintings are taken from other locations, from his memory or even from his imagination.

"I make conscious choices about the images I show based on morality. I don't paint crashing cars and flailing arms. You don't need those to express passion," he says.

Hunt says he paints to communicate. He explains, "I am expressing emotions. Also ideas, but I think ideas are less important in art than emotions. In my work the focus is on the emotional effect the work is going to have on the viewer. At an exhibit once a woman broke into tears looking at *New Year's Eve*. That's what my painting is for.

"I'm painting images that interest me. I'm not always sure why when I start out. I find out more and more why it's interesting to me as I go along and even after I'm done. Like the image of a dog in a truck keeps coming back to me. Each time I see a truck drive by with a dog in it, it's like a bolt of lightning in my mind. I suppose it's the contrast of the dog and man, the feral and the mechanical."

Despite the rigorous reality of Hunt's oil paintings, he never does many preliminary studies. He explains, "I think through the image first. I don't do a lot of preliminary drawings. I do some, but they're things I'll throw out. There's nothing significant about them. Most of the work goes on in my head. Then at some point the image clicks."

He doesn't deliberate about the composition; that is automatically worked out as he develops the image. He says, "I think as an artist matures, you go more and more on automatic. I'm barely conscious of the brush in my hand when I'm painting—I'm watching where the line is going to go."

He may visit the site of a painting many times, but he paints in his studio with all kinds of reference material, sketches, a lot of written notes and photos. The photos are not to copy because he is constantly rearranging objects and adding objects from other locations and his memory. He says he never uses photos as his source for color because photographic color is not accurate.

He is very systematic in his painting. He knows, for instance, when he is doing the underpainting, that he is going to be covering it with five glazes and what color each glaze will be.

He executes his paintings in sections. He completes one area. Then he paints the section next to it and adjusts the relationship between the two with glazes, painting a section and adjusting, painting another section and adjusting until the whole composition is complete.

"I am working on a still life now. All that's left is a wicker basket and I am dreading it—all those ins and outs and color changes," he says with a moan. "I am going to need a week of eight- to ten-hour days. In my style of painting there are no shortcuts. I have to paint each little bit. But at least at the end, I will know how to paint a wicker basket."

He explains, though, that even in a still life, he is not painting things—he is painting light on things and "atmospherics" indoors as well as outdoors. To enhance the mood of a piece he may exaggerate the lighting effects somewhat, such as dust particles in a shaft of light.

Because of Hunt's need to communicate, the viewer also becomes part of the painting. "My work is to be seen as a place, an illusion of a place as if you were looking in a window or a mirror. Implied in the painting is the viewer and that the viewer is standing in a particular place.

"There is a real sense of isolation in being an artist. I have been self-employed for twenty years and my studio is in my house, where I live alone. But I don't feel lonely when I'm painting. When I'm painting, I'm talking to the painting. The painting is talking to me and there's that gray eminence in the background, that person who is going to see the painting. I'm talking to that person too."

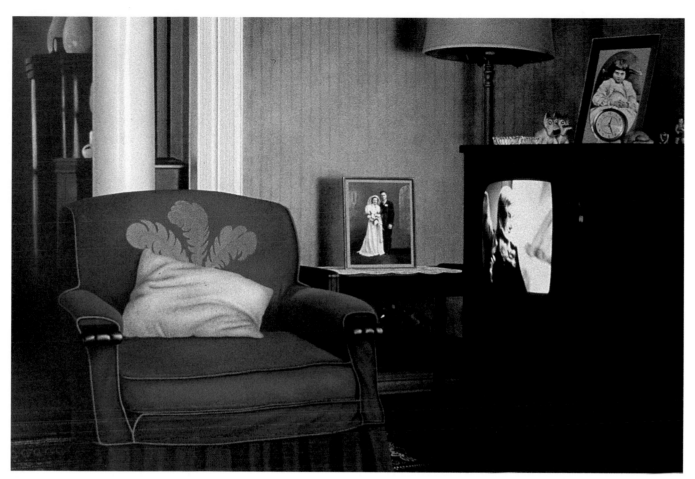

New Year's Eve
David Hunt, 35″ × 50″, Oil
Hunt says, "This painting of my elderly grandmother's apartment was painted from memory using as many objects as still remain to paint from life. It is a meditation on memories and loneliness."

Demonstration: A Passion for Communicating

Step 1: On a canvas primed with three coats of acrylic gesso, David Hunt uses pencil for a detailed linear drawing of his composition. He paints the floor, curtain, furniture and landscape alla prima and blocks in the wall with a thin wash just to indicate the values. The straight edges are done with a good-quality flat brush. If an edge needs to be softened or blended, Hunt uses a medium-sized round brush dipped in medium and flattened with his fingers.

Step 2: He adjusts the colors of the wall and curtain with many glazes and a scumbling technique. He continues to adjust color and value of the total painting as each new area is defined.

Step 3: He adds the dark values of the furniture and deepens other colors to maintain the value relationships of the composition. In areas of sunlight or reflected light he keeps edges and surfaces soft to suggest the slightly dusty air in the room and the way this kind of air bounces light around.

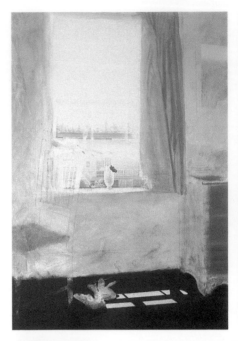

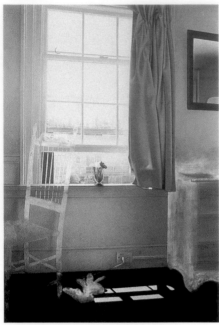

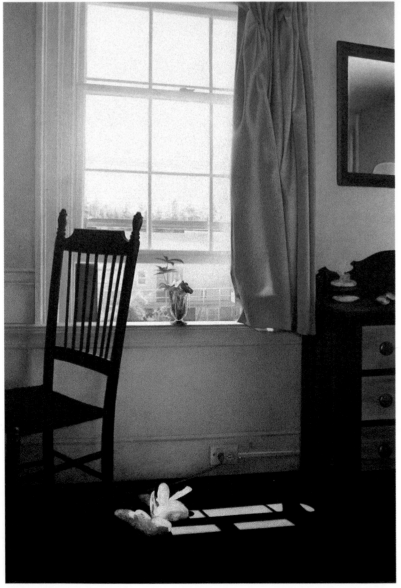

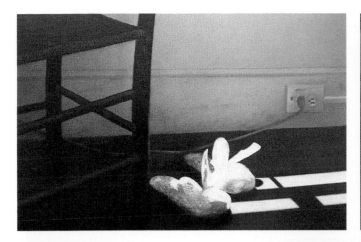

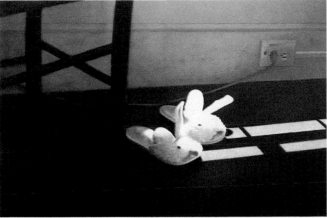

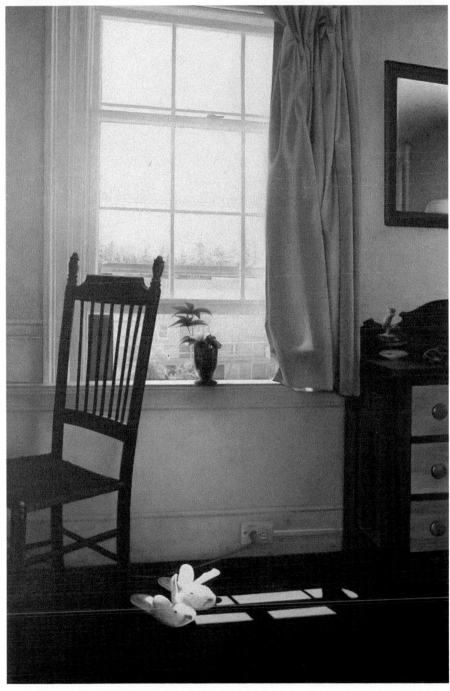

Steps 4 and 5: Here you see the development of the bunny slippers and surrounding area from Step 3 to the finished painting. Notice the limited amount of underpainting; only the basic value changes of light and shadow are indicated. In the final stage the detail is kept minimal in the brightest light. Also apparent in comparing the two stages is the warmth of color added to the wall, slippers and rectangles of sunlight with successive glazes.

Summer
David Hunt, 46″ × 30″, Oil
This painting took 242 hours of studio time to complete. Because each of his paintings demands such a great time commitment, Hunt must plan each composition so that it not only works visually, but also expresses an important thought or feeling. He explains, "Old furniture suggests a continuity with many summers past, but the bunny slippers and sunglasses tell of a modern presence, here but to briefly partake of the gifts of the world."

Sheriff of Bullet Valley
David Hunt, 58″ × 31″, Oil
Hunt intended this painting to be a meditation on childhood as well as a tribute to Carl Barks, who wrote and drew the Donald Duck stories. The room and window view are from the house where the artist grew up.

California Church
David Hunt, 18″ × 22″, Oil
This painting takes its drama from the strong contrasts. The values go from very light to very dark with few grays in between and the shapes are rounded natural forms against straight architectural forms.

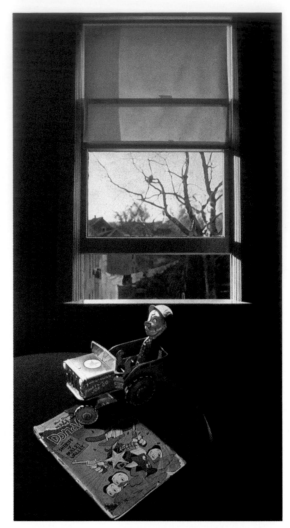

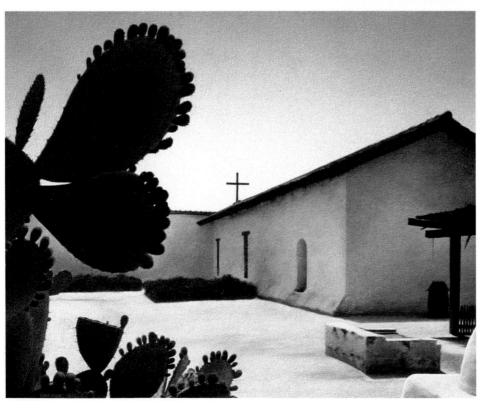

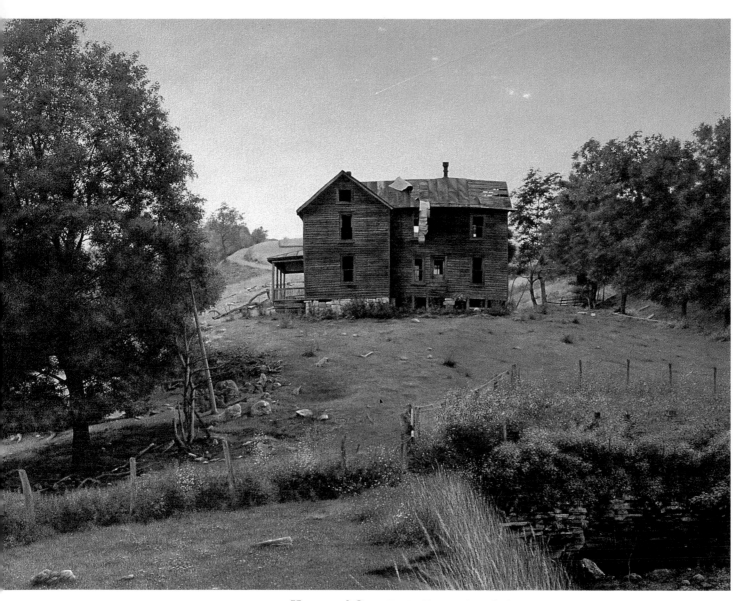

House and Cave, David Hunt, 30″ × 40″, Oil
The house in this painting is one that Hunt discovered on a cave-exploring trip to West Virginia. He made three trips to West Virginia to gather material. The scene is very faithful to the actual place except for the cave in the foreground, which is a composite of many caves he has known.

TWO

CRAZY ABOUT COLOR

For some people color is like air—it's so much a part of what surrounds us that they don't even notice it. For others, though, color is what gives zest to what they see. For them there is nothing matter-of-fact about color. That's not simply a blue sofa; it's a brilliant ultramarine with cerulean accents and deep indigo shadows.

Some colorists are like bird-watchers, content with seeing and labeling so that they can reproduce color accurately in their own art. Some are more adventurous, creating relationships, and especially unexpected relationships, of color. What will happen if I use a complementary green for the shadows on that reddish skin? Can I stipple red and blue to get the violet of that sunset?

Artists who are passionate about color go beyond an academic knowledge of color theory. Yes, they study the theories, but only as a jumping-off point for their own adventures and experiments in the world of color. And it is a world of its own. Joe Anna Arnett declares it would take more than a lifetime for her to explore the entire color world just of the irises in her backyard.

There is no need for me to give a full course in color theory here; many wonderful books already do that. Instead, I'll just touch on some of the main elements that passionate colorists explore.

Any given color consists of several components. *Hue* or *chroma* is what we generally refer to as color, identifying something as red, green or blue. A color wheel shows the full spectrum of chroma.

Value is the lightness or darkness of the color. Every stroke of color has a value, but this can be one of the more difficult characteristics to judge. We tend to think of some colors as always light or always dark; for instance, we think yellow is light and blue is dark. However, there are many instances where a yellow is actually darker than a blue. The only way to determine value is through comparison, placing one swatch of color next to another. Put a stroke of yellow next to white and it looks dark; next to black it looks light.

A valuable tool in assessing value is a *gray scale*. This is usually a gradation of grays going from white, the lightest value, to black, the darkest.

Temperature refers to the warmness or coolness of a color. Again, we assume that certain colors have an inherent temperature. We think green is cool and red is warm. This is not always true. There are warm greens and cool greens as well as warm reds and cool reds. Compari-

son is also the way to determine temperature. Look at a leafy tree in the spring. The new growth is not only lighter, but also a warmer green than the older leaves.

Some artists say that every light has a color temperature. It is either a warm or a cool light. When the light is warm, every color in the light will be warm and every color in the shadow will be cool. They say the opposite is also true. If the light is cool, then the shadows will all be warm colors.

Intensity refers to how bright or pure the color is. When you mix equal amounts of two complements together—red and green, yellow and purple or blue and orange—you create gray. If you mix a smaller amount of a color into its complement, say a small amount of green into red, the larger amount of color will dominate. You will still have red, but that small amount of green will make it a duller or grayer red.

By placing brighter against grayer colors, you can intensify the impact of the bright colors. When all of the colors in a painting are of the same intensity, they can overwhelm the viewer. Grayed colors provide space within a painting for the viewer's eye to rest.

Density has to do with how transparent or opaque a color is. Even though you are using exactly the same pigment, it can appear different when it is thinned with some kind of medium. This is very easy to see in watercolors. A thin wash of red where your brush contains a lot of water and very little paint will seem to be a different color from the same red applied very thick.

All five of these components come into play when you are mixing colors on your palette. A simplified example: You want an orange, so you mix red and yellow. That's your basic hue or chroma. You want a dark orange, so you probably use more red than yellow or maybe a small amount of

brown. That's your value. To get a cool orange you add a touch of green or violet. Both of those colors contain the complement blue, so they will probably gray the orange a bit also. That's your intensity. You want a transparent orange, so you add water or another medium to dilute the pigment.

One of the best ways to learn about color is simply to mix colors. Paint a swatch of each color you mix and jot down what pigments you used to get that result. The more you practice this exercise, the more easily you will be able to create whatever colors you need.

Beyond the colors themselves, what makes color exciting is the relationships between colors. I already mentioned *complements*, the colors that are opposite each other on the color wheel. Complements work like magic. Mix them together and you get gray, but paint them next to each other and you get electricity. When you want a color to look like it is vibrating, use it next to its complement. Pop art artists made entire paintings look like they were vibrating by alternating stripes of complementary colors.

What happens when you put related colors next to each other, yellow next to orange or blue next to green? The colors appear to blend into each other. A good way of moving the viewer's eye from one area to another is to paint the areas in related colors.

The Impressionists used visual blending, putting individual strokes of different colors in the same area. When looked at from a distance, these distinct strokes seem to blend into a solid mass of a different color. For instance, if you place dots of yellow among dots of blue, the color will blend to green at a distance. This works most effectively when the component colors are of the same value.

Violet Skies

Donna Levinstone, 20″ × 18″, Pastel
What makes the color in Donna Levinstone's landscapes so striking is her use of contrast. Here, for instance, she juxtaposes warm pink against cool blue and she extends the values of the colors from very light to very dark.

Fertile Period 3

Alberta Cifolelli, 60″ × 50″, Oil
Although the heart of Cifolelli's paintings is color, the artist doesn't plan or even think about the colors ahead. She works intuitively, beginning each composition with a few simple shapes of color and then adding whatever colors the painting itself seems to call for.

Watermelon and Brass

Joe Anna Arnett, 14″ × 16″, Oil
An important component of color in a composition is the color in reflected light. The pink and red of the watermelon is not only seen in the fruit itself, but also in all the reflections of the fruit. The most obvious are the reflections on the metal pot, but notice also the red reflections in the cast shadows and on the other fruit.

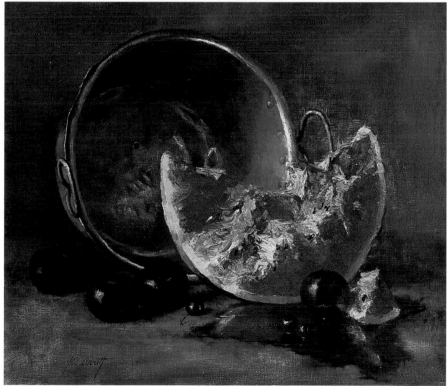

Place strokes of related colors together. By combining strokes of red, orange and violet, for instance, you can create a more powerful red than the pure red color out of a tube.

The two elements of color needed for a successful painting composition are *harmony* and *contrast*. Harmony is achieved by painting with related colors, by limiting the palette and by repeating colors within the image. Another useful technique is using a "mother color." That is one color that you blend with most or all of the other colors in the painting.

Totally harmonious colors can often look dull and boring. To avoid that effect, it is important to introduce contrast, as Martha Saudek does in her demonstration painting, *Bouquet Canyon Creek*, below. Cool colors against warm, brilliant colors against gray, light colors against dark, and the use of complements will add drama to your compositions.

Demonstration

Step 1: From the beginning Martha Saudek chooses a dominant hue or color for her painting. Here it is green and she begins to establish it early by using green to sketch in the shapes of the image.

Step 2: Besides the dominant greens, she uses mostly related colors. You can see both blue and yellow here, the colors next to green on the color wheel.

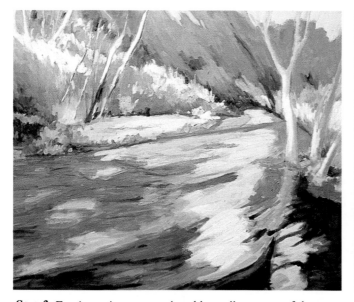

Step 3: For dramatic contrast, she adds small amounts of the complement to the dominant hue. Notice the small strokes of red.

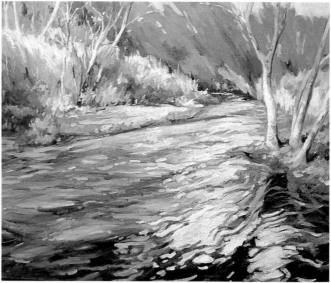

Step 4: She develops the texture of the rippling water with individual strokes of the same colors she has already established in the painting.

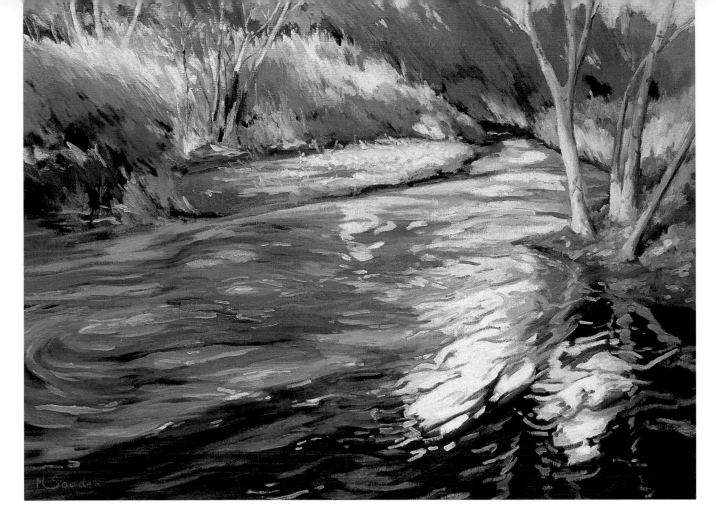

Although some teachers insist that their choice of colors is best for every student, I believe it's important for artists to explore color on their own and discover what combination of colors will best express their own vision.

Some artists eventually develop a selection of colors that they use consistently. Some, like Phil Salvato, have one palette for portraits and another for landscapes. Some artists choose different colors for every subject and mood, letting the individual painting itself dictate the palette.

Remember that colors exist in relationship to other colors. I have learned that the very same stick of pastel will look like two totally different colors when applied to different colors of paper. An underpainting will change a particular color as will the colors that surround it.

Passion for color can take two forms. One is the relentless pursuit of understanding and reproducing *local color*, the color that is actually there. The other is a desire to invent colors and color relationships that convey the mood rather than the literal appearance of a scene. Both provide painting challenges.

Bouquet Canyon Creek
Martha Saudek, 24″ × 30″, Oil
In the final painting you can see that the overall color is green, but within that green there is a rich variety of other colors. One of the interesting things Saudek has done with color in this piece is establish a focal point in the upper right corner by juxtaposing bright strokes of red, yellow, green and blue.

Changing Color

Go outside in the early morning of a sunny day with a selection of colors in any painting medium. Pick an object in nature and paint a swatch of color on a piece of paper or canvas that exactly matches the color of your subject. Put that swatch of color aside.

Two hours later go back to the same subject and paint another swatch of color that exactly matches the subject now. Put that one aside.

Continue the process every two hours throughout the day. At the end of the day, put all of the color samples side by side. If you have been sensitive to the color, you will see that the color has changed as the daylight changed.

Mid-day at the Schulers'
Philip Salvato, 16″ × 24″, Oil
In his landscape painting Salvato uses color in an expressionistic way, concerned more with the mood of the color than the actual visual reality. Notice how he repeats colors throughout the painting to create color harmony.

This is the palette Philip Salvato uses for outdoor location painting: Hansa yellow, alizarin crimson and ultramarine blue.

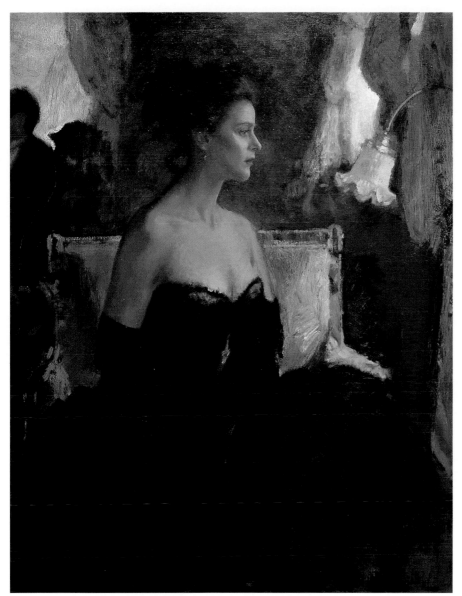

Bobbi Robbe

Philip Salvato, 48″ × 36″, Oil

In this portrait you can see how Salvato mixes brighter colors with rich flesh tones to get a composition where the background colors are strong, but do not overpower the figure.

This is Salvato's palette for portrait or figure painting:

1st row—Warm mixtures of yellow ochre and ivory black.

2nd row—Venetian red mixed with top row.

3rd row—Venetian red to Indian red.

4th row—Venetian red mixed with fifth row.

5th row—Cool mixtures of yellow ochre and ivory black.

6th row—Ivory black values.

Very top—Bright colors, if needed, can be mixed with value tones.

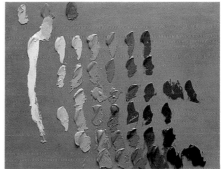

Harnessing Color

Color is like an eighteen-horse wagon. You're holding the reins, but if you don't understand them and have the power to control them, they're going to run away with you. Most students are terrified to use color. They are afraid of the emotion of it, the power. They are afraid of losing control, but there comes a point where you have to risk it." Thus speaks Kay Polk, whose portraits are notable for her vivid, unexpected use of color.

One of her heroes in the use of color is the Spanish artist Joaquin Sorolla. Looking at his paintings, she saw the power of reflected colors in bright sunlight, which she now uses in her own work. She points out that the sun bleaches out the colors in direct light, but the reflected light picks up all the colors from the surrounding environment. Thus, bright yellow, green or magenta will appear in the shadowed skin tones, reflected onto the light skin colors from the surrounding landscape.

Polk admits, "At first I was very timid about color. Emily Guthrie Smith was the one who told me that every color has a complement. That was the key. She said, never be afraid if a color is too bright, too strong, too forceful because you have the tool in your hands to knock that color down."

Kay Polk started drawing when she was so young she can't even remember. It was so easy for her, she thought everybody could do it. She says she was a shy, anxious-to-please child, raised in a military-like family. Art was her outlet for expressing herself. From the very beginning she was fascinated by people's faces and she started to study portraiture when she was still in high school, taking lessons from Dallas portrait artist Ramon Froman. Later she auditioned for and was accepted into the classes of Emily Guthrie Smith at the Fort Worth Museum.

Marriage brought a hiatus to her art career. Then when she became "suddenly single," she gave up the four-thousand square-foot house with a maid in a rural town and moved to Dallas where she could be a portrait artist. After three years as an illustrator she began her portrait career and only three years after that she had a year-long waiting list for her portraits.

Unlike many portraitists, pleasing the clients is rarely a problem or even a consideration for Polk. It happens as a natural result of the way she approaches each subject.

She says, "I never think about pleasing the clients until the painting's finished and then I hope I am going to get paid. When I start a new commission, I think, here is this new person like a gift all wrapped up in paper. It's just a matter of unwrapping it until you find what's special, not necessarily beautiful—maybe their sensual side or what's endearing. It's the mystery that keeps me going. No two people are alike."

Especially with children, Polk paints from photographs. She likes to shoot several rolls of film, getting a sense of the subject's personality while she is photographing. The photo is a guide to features, pose and background, but only a reference for color, which she will adjust and alter to express the light and the mood.

One source of her success in capturing likeness and expression is the method of defining the image with shapes rather than lines. She never projects the subject onto the canvas to lay in the contour lines and reference points. Instead she looks at the photo to find the shape of the head, the eye sockets, nose, mouth and shadow patterns. The only two lines she focuses on in the beginning are the center line of the face and the expression line of the mouth.

"I find the fewer lines I use, the freer I am to push, pull and adjust the shapes until the relative proportion of one shape to another on the face begins to resemble the likeness. Lines are like fences. When they look back at you, they seem so set and unmovable.

"For the same reason I don't put in the eyes at first, just shapes. As soon as I know where the sockets are, I'll put in the shape of the eyelids and iris, always making the shapes larger rather than smaller so I can carve into them. It's much easier than trying to make something larger and tons easier than working around lines.

"The shape of the shadow under the nose, under the tip and the cast shadow are the most important shapes of noses. Noses are not drawn. They are formed by the shadows around them. The same is

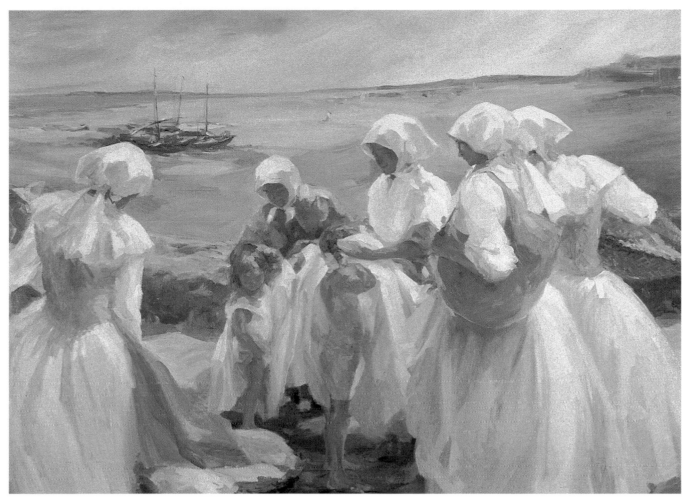

true of mouths—it's the shape of everything around them. Frankly, I think mouths are like teenagers. Mouths tend to do exactly what you don't want them to do, as if they have a mind of their own. If you hang in there and stick to the basics, the mouth will work out . . . usually. Just like teenagers."

Polk paints her portraits and other subjects in either pastel or oil. She works from dark to light, letting the final light accents be the thickest strokes.

She says that previously when something was not working she would "stubbornly, compulsively" continue to paint on it until she thought she was going to wear out the canvas. Now she sets it aside until the solution reveals itself. She keeps three pieces going at the same time. She says getting away from the problem is the best way to deal with blockages. This may mean getting away from the painting, and sometimes getting away from the studio. She says the mistakes pop out at you when you're not looking at them; of course, this happens after years and years of making mistakes.

Ladies on the Beach
Kay Polk, 30″ × 40″, Oil
This painting was inspired by looking at the paintings of Spanish artist Joaquin Sorolla. The colors were a vast departure from Polk's usual portrait palette and she says her palette has never been the same since.

Demonstration: A Passion for Color Shapes

Step 1: Kay Polk is painting with pastel on linen glued to a Masonite panel. The linen is sealed with two coats of rabbitskin glue, which works as a resist so that the first colors go on slowly. She uses rags, stumps, paper towels and fingers to rub the pigment into the fabric.

Step 2: Because of the resistant ground she is able to build up shapes and colors slowly. With portraits, shapes are primary. Capturing a likeness is simply a matter of refining the shapes and the relationships between the shapes.

Step 3: She applies color, wipes it off, applies more color and so on. Because of the gradual buildup of pigment, the image seems to grow out of the canvas. This allows the artist time to revise and refine as she goes along.

Step 4: By now the color is beginning to take shape. Polk is as concerned with value and color temperature as with hue. It is especially the value that gives three-dimensional form to the face and figure.

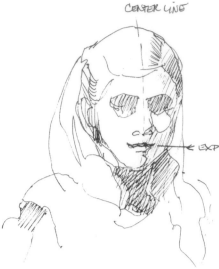

CENTER LINE

START WITH SHAPES. THEN SHAPES WITH-IN SHAPES.

← EXPRESSION LINE OF MOUTH

Polk is concerned with only two lines when developing a face — the center line and the expression line of the mouth. Aside from those, the entire portrait is developed with shapes. She places the main shapes first and then gradually refines them until the likeness becomes apparent.

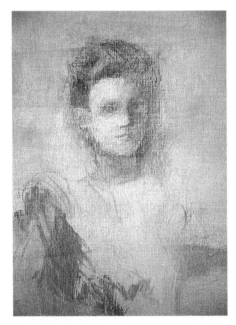

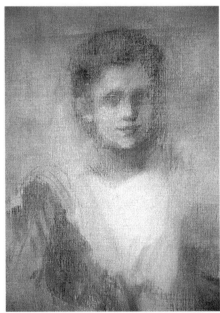

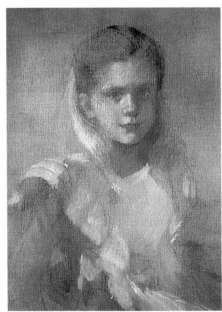

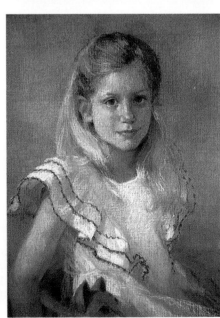

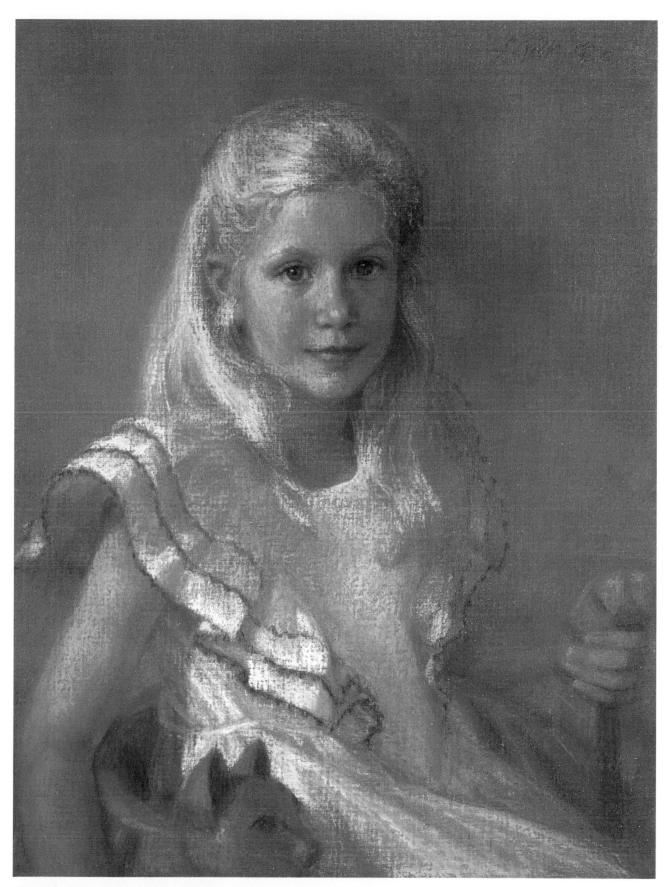

Countess Christina, Kay Polk, 26″ × 20″, Pastel
Even in this soft and delicate rendering of blond Christina, Polk has used a rich and
unexpected variety of colors. Look at the yellow and violet accents in the face.

Portrait of Hill
Kay Polk, 18″ × 14″, Pastel
This is an excellent example of how Polk models form with individual strokes of color. The strokes are especially apparent in the shadowed areas, which are picking up strong reflected color from the environment. From a distance they blend into solid masses of color value, but up close they create a highly textured surface.

Detail 1: Looking at the hands and arms you can see how Polk models form with the direction of the strokes, rounded strokes to show a rounded form.

Detail 2: In the areas of bright sunlight like the top of the boy's head and shoulder, the colors appear bleached out. The shadows, however, pick up all the bright reflected blues, reds, violets and greens of the hot day.

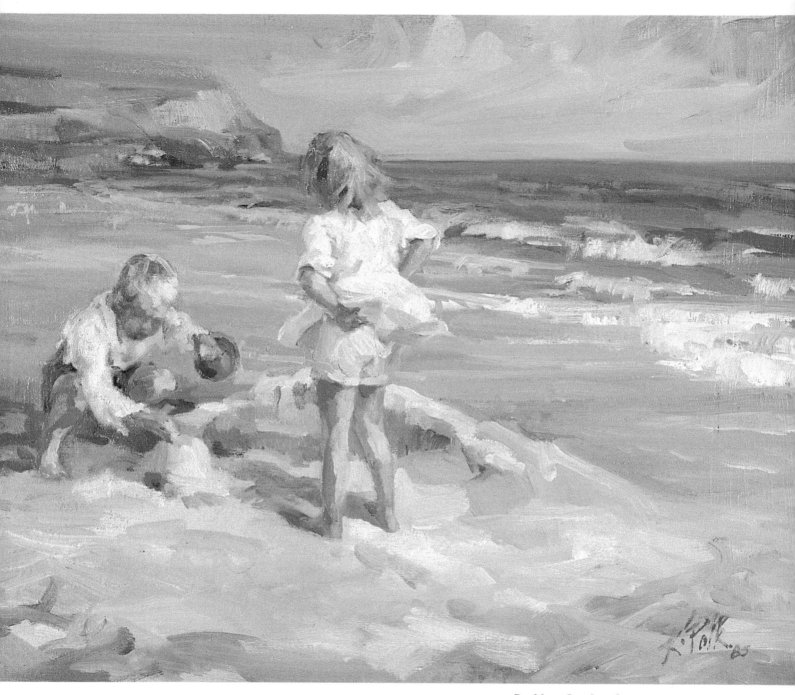

Building Sandcastles
Kay Polk, 11″×14″, Oil
When using figures in a larger scene, rather than a portrait, Polk focuses more on shape and color than specific anatomical details. The three-dimensional form is achieved with careful placement of highlights and shadows.

Beyond Fashion

Richard Rackus says, "I did modern art for a while, but it was a nervous sort of art they were doing. If you go by just fashion, in a few years it's out of fashion. If you are within a tradition, there's more substance. My art stems from the beginning of the Renaissance, in the continuum of what we've done in Western art. Some people call me a revivalist; they say I'm bringing something back. I just do what's natural. It's the way I've always painted."

Although Rackus doesn't particularly care about fashion or the artists who are fashionable (he refers to Georgia O'Keeffe as "that Irish woman who lived in the desert—I exhibited with her once"), he has become a fashionable painter with the resurgence of plein air painters in California.

His landscapes are characterized by graceful compositions and glowing colors, giving the viewer a sense of being outdoors in the broad daylight. He says the artist has to remind people that light and color are romantic. His favorite colorist is Claude Monet, who was concerned with "the relationship of one color to another, like developing a symphony."

Rackus studied with Henry Lee McPhee and Rico Lebrun at Chouinard Art Institute. Today he lives and paints landscapes in Ojai, California, where there are infinite subjects for his outdoor paintings.

Rackus says, "While I do all of my painting indoors in my studio, I still need to go outdoors to capture the mood and color tones that make up the landscape. When I am set up in the field, the main objective is to establish the state of the landscape at this particular moment. This I can do quickly with a small canvas. I establish the key of the painting by the large mass tonal relationship of tree to mountain, mountain to sky, sky to cloud, and sky to ground plane.

"One does not copy what one sees in nature, but must modify and rearrange the subject matter to conform to one's conception.

"After the tonal relationships have been established out-of-doors, I return to my studio. Here I develop small conceptual pencil sketches in proportion to the chosen canvas. One idea leads to another. Sometimes I have photos for reference, but I never copy them, for a true conception has its own unique configuration.

"I decide if the painting will be dominantly cool or warm and what color will, if possible, be mixed with each tone throughout the canvas for unity. The intensity of colors will be considered and kept constant. For example, high intensity for a sunny day, low intensity for a cloudy day."

He says that to have color work, you must have harmony. For his palette he starts with a family of related colors from the spectrum. Then he adds a small amount of the complement "to lower the chroma." He explains that the eye is disturbed if it sees too many colors and values; the painting should read simply.

In addition to the related colors, he adds a complement to create what he calls harmonious discord. If the family of chosen colors includes yellow, yellow-green, green and blue-green, he will add a red, careful to maintain the consistency of color temperature. That is, the red will be a warm red close to the yellow.

As he paints, he introduces similar colors of the opposite temperature. A sky, for instance, will have strokes of warm blue and cool blue to give more vibration. He explains, "On every surface you have warm and cool. Within each area of the painting it appears as one color. The temperature contrast should never be so strong that it jumps out and destroys the local color."

He paints on a toned canvas. Rubbing the canvas with raw sienna will create a yellow tone that adds warmth to the light in the painting. Leaving some of the undercolor showing through it also helps unify the color of the painting.

The painting is done with crisp, individual strokes. If a stroke is not right, he scrapes it off and tries again. He says, "A stroke is right if it has a certain vitality. If you fiddle with it too much, you lose the truth of the moment."

The Pink Moment, Richard Rackus, 16″ × 20″, Oil
"During sundown in the village of Ojai," says Rackus, "the atmosphere takes on an enchanting and mystical glow. The landscape is awash in an atmosphere filled with a rose pink light. The locals call it 'The Pink Moment.' "

Demonstration: A Passion for Glowing Color

Step 1: Richard Rackus begins by toning the canvas with raw sienna, diluted with turpentine and a drop or two of Damar varnish. He rubs the paint on with a rag, leaving a yellowish tint. He sketches on the basic shapes with red violet and defines his large shapes with thin washes.

Step 2: He develops the middle values of sky and water first. He defines the foreground shapes by painting the blue negative space.

Step 3: He begins to develop cloud shapes in the sky with loose strokes and soft edges. He starts to explore the light patterns on the trees.

Step 4: He tightens up the cloud forms and plays with light on the water and foreground shapes.

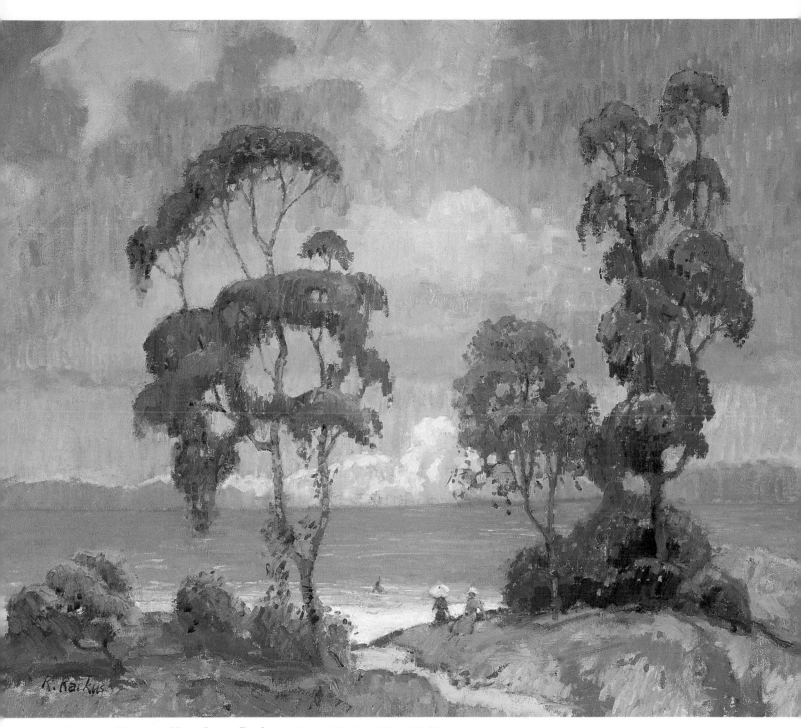

Summer Afternoon Near Santa Barbara, Richard Rackus, 20″ × 24″, Oil
In the final stage of the painting, he gives more mass to the foliage and develops the
foreground color. The bright yellows and golds of the underpainting show up now only
where they shine through the later colors. He intensifies the colors and adds the tiny
figures to the foreground. This painting shows the three ways Rackus develops color. In
some places he puts down one solid stroke of color and that is it. In other areas, like the
sky, he paints many strokes of various hues next to each other and lets them blend
visually. The third way is to build up colors with many layers of scumbled or transparent
color to let the previous strokes show through.

Ventura River

Richard Rackus, 24″×30″, Oil

Rackus begins each painting with several small conceptual sketches in proportion to the canvas. The purpose of these black-and-white studies is to formalize the composition. The sketch serves as a guide to the value pattern. Within that value structure he is free to invent the color scheme that will best express the mood of the scene.

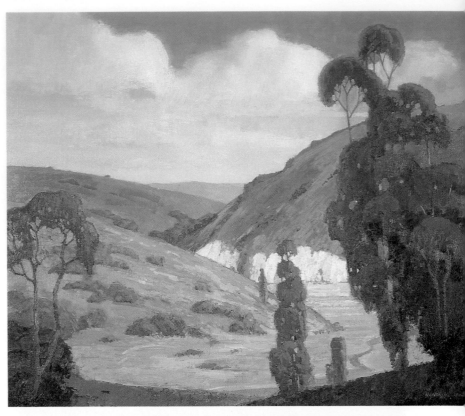

Eucalyptus Trees, Ojai, Richard Rackus, 16″×20″, Oil

Notice the use of complementaries in this painting. Throughout the clouds and sky, Rackus has mixed pink or violet into the green and green into the pink to soften the colors and create an overall color harmony. Notice the individual strokes of many colors that create the cloud shapes.

Sespe Creek
Richard Rackus, 24″ × 30″, Oil
Rackus says, "One of the most important objectives in outdoor painting is the observation of light. One paints the light that one sees, the color of the sunlight, under various atmospheric conditions, projected on the landscape. This presents an opportunity for optical mixing such as many small brushstrokes of different colors, one against the other."

THREE

TURN ON THE LIGHT

Light is a difficult concept for new artists to understand—"Of course, I know what light is. You flip the switch, you have light. You turn it off, you don't. What's the big deal?" More experienced artists know that light is the foundation of every painting. But what does that mean?

When you look at a scene, any scene, it is light that makes the various objects visible. If there is too little light, you can't see it at all. If there is too much light, you can't see it either. In addition, the way the scene looks is determined by the kind of light. Where is it coming from? Is it direct or diffused light? Is it natural or artificial light? What surfaces are reflecting light besides the original source?

Besides the purely mechanical function of seeing, light has a powerful effect on the mood of a scene. A dark view generally feels hidden, ominous, unhappy; a bright scene is more cheerful, hopeful, lively. A scene that is evenly lit is calm, ordinary; a scene with bright highlights against dark shadows is dramatic.

The arrangement of light shows us form. The square box looks solid only because of the differing value planes. We are convinced of its solidity because it has a light side and a dark side.

Light has a profound effect on our perception of color. The same bright red dress can appear a washed-out pink in intense light or a cold maroon in shadow. In bright sunlight skin may appear almost colorless in highlighted areas, but the shadows will pick up all the intense colors from reflective surfaces, making the skin appear to be blue, purple or green.

The location of the light source affects where the shadows fall, their shape, and how intense they are. The shapes of light and shadow become building blocks in developing a composition. The pattern of light and dark values is the foundation on which the rest of the composition stands. If the value pattern is interesting, the painting will be visually interesting regardless of subject, color or paint application. If the value pattern is unbalanced or undefined, the painting probably will not work.

One of the most intriguing aspects of light is its temporal quality. Landscape painters quickly discover the changeability of light. A particular condition of light exists for only a moment and capturing that one specific moment in time can be the greatest challenge for the plein air painter. The time of day, the time of year and the weather conditions are all factors that contribute to the

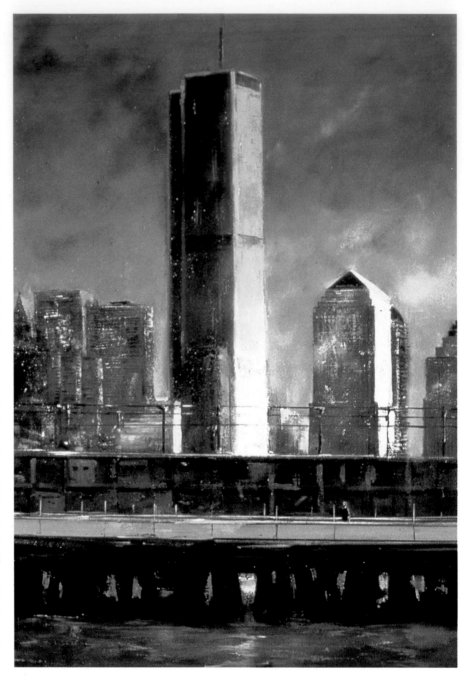

quality of the light. So when an artist truly captures the light, he or she shows the viewer all of those things, the time of day and year and the atmosphere as well as the physical subject of the painting.

Some artists love the academic exercise of studying light. Place a white ball on a white table with a single light source. These artists are content to sit for hours analyzing the five value levels. Where is the direct light falling, the indirect light, the shadowed area, the re-

Pier 48 Revisited
John Dobbs, 52″ × 36″, Oil
Look at how the use of light in this painting strengthens the composition. The light and shadow on the buildings create bold vertical rectangles. Opposing this are the light and dark horizontal shapes in the foreground. The intense spot of sunlight shining through the very dark shadows, lower center, becomes a dynamic focal point.

flected light and the cast shadow? The natural phenomenon of light in itself is fascinating to them.

For other artists their passionate involvement with light has to do with how light affects the natural world around us and how it influences our feelings about that world.

For the artist who wants to make powerful, dramatic statements, light is an indispensable tool.

Can you learn to see light? You might know that there are all sorts of wonderful subtleties and nuances in light because that's what other artists tell you, yet still be unable to

distinguish them yourself. Are you doomed to a life of visual deprivation as tone deaf people are with music?

Fortunately, anyone who can see can learn to see light. I was a slow learner myself so I know it's possible. I started with cast shadows. Of

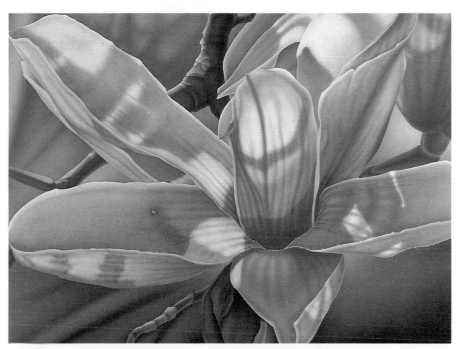

Magnolia
Norma Auer Adams, 30″ × 40″, Acrylic
In this airbrushed acrylic painting Adams has taken just a fragment of a flower and blown it up to 30″ × 40″. What makes it interesting enough to hold up in such a large format is the pattern of lights and shadows on the blossom.

Taking a Meeting
Carole Katchen, 21″ × 29″, Pastel
The single light source in this painting gives it a dramatic impact it would lack with more diffused lighting. The intriguing facial expression is almost secondary to the strong contrast of bright light and dark shadows.

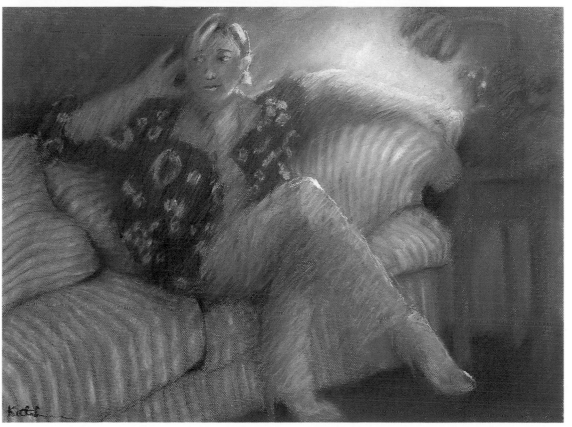

all the effects of light, cast shadows are the most obvious and easiest to distinguish. As you walk through your daily life, notice the cast shadows. Where are they falling? In what direction do they seem to be pointing? How dark are they and what is their shape? Just look at the shadows at first; don't worry about what is causing them. Just keep looking until the first thing you see in any scene is the cast shadows.

As you become familiar with shadows, you will begin to see patterns. All the shadows are pointing in the same direction. All the shadows are long and narrow. All the shadows are on the same side of the objects. Whenever you recognize a pattern, look for the light source that is causing that pattern. If you are outdoors, notice where the sun is. Indoors look for one powerful lamp or a window. When all the cast shadows form a repetitive pattern, you know that there is one definite light source causing it.

Now you can experiment with setting up a strong light source to create your own shadow patterns. In a dimly lit location, put several objects on a table. Point a spotlight at the objects and notice the cast shadows. Move the light around, higher and lower, closer and further, on the right or on the left. Notice how the cast shadows move in relation to the light source.

From cast shadows you can move on to observe the light and shadow on objects. Again look for patterns and then notice the relationship between the pattern of values and the light source. Gradually you will find yourself seeing those elusive nuances—how sharp or soft edges appear in differing light, the changes in color and color temperature, the existence and effects of reflected light. Once you see light, you can use it in your paintings to express the passion you feel for your subject.

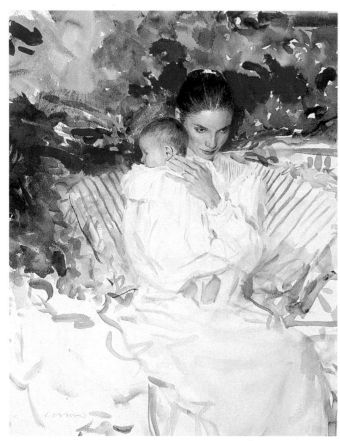 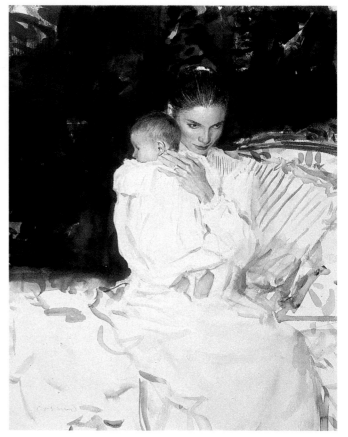

Secure, Henry Casselli, 22″ × 17″, Watercolor
Casselli first finished this painting with a light background, then decided the bright colors detracted from the subject. In these two versions of the piece you can see how much more dramatic the light figures of mother and child become when they are placed against a very dark background.

Mountain Series I, Donna Levinstone, 11″ × 16″, Pastel
Donna Levinstone loves to work in black and white because it gives her the opportunity to focus totally on the drama of light and dark.

Monhegan Wildflowers, David Hunt, 18″ × 24″, Oil
Hunt created an unexpected view by making the interior of this scene dark. Thus the view through the window becomes more prominent and the vase of flowers is seen as a dark silhouette with a few brilliant accents.

Morning in Idaho, Martha Saudek, 24″ × 36″, Oil
Saudek creates the illusion of spatial depth by using value contrast, placing the most intense lights and darks in the foreground. As the landscape recedes, values become soft, middle gray tones.

Demonstration

This is a photo of Jo Anna Arnett's still life setup arranged with a single light source for maximum drama. Arnett always works from the actual objects rather than photographs so that she can see the subtle nuances of light and shadow.

Step 1: She begins by blocking in the main shapes of the composition.

Step 2: She adds color and shows the value differences between the light side and the shadowed side of the objects.

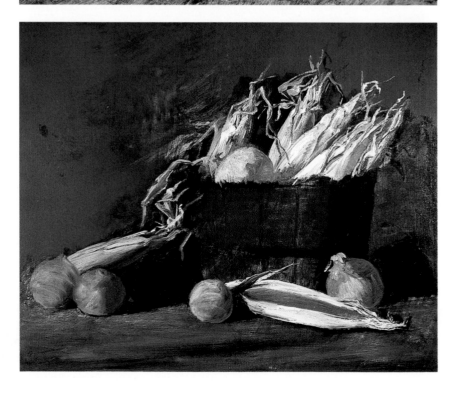

She Kept a Fine Garden
Joe Anna Arnett, 18″ × 22″, Oil
Arnett refines color, value and detail to complete the painting. Notice that she has added a glass jar on the left; this provides a necessary bright accent in that part of the painting.

Color Your Light

Set up a still life with a single spotlight for your light source. Put a colored gel over the light. You can buy gels at camera stores. Use a strong, warm color like yellow, orange, red or red-violet. Paint the still life in that light. Pay special attention to the temperature of color in the highlights and in the shadows.

Change the gel to a strong, cool color. Do a second painting of the same subject in this light. Again concentrate on the color temperature.

Compare the two finished paintings with special attention to the differences in color and color temperature.

ARLENE CORNELL

The Subject Is Light

In Arlene Cornell's paintings it is impossible to separate the subject from light. The barn and pasture are not just a barn and pasture; they are a barn and pasture in crisp winter sunlight with crisscrossed shadow patterns on the snow. This is a specific moment in time, a specific moment in light.

She doesn't consciously look for patterns of light and shadow; it is automatic. Painting a boardwalk, she picks a point of view at sand-level and the repetitive shadows under the structure pull the viewer's eye into the painting. Her view of a weathered veranda happens to be in the late afternoon when the cast shadows form dynamic ladders across the bottom of the composition.

All she says about light is "I like warm light. Most of the subjects I paint are very early in the morning or late in the afternoon when the light is warm." But in every subject she paints, the light is crucial to the dynamics of the painting.

"I cannot say exactly what motivates me to paint a particular subject," she says. "I see something and I know I must paint it. It strikes an emotional response within me. My paintings are an attempt to crystallize a moment in time."

Watercolor is the perfect medium for her to convey light. She locates the light areas of a painting first, using the sparkling whiteness of the paper to show direct light. With frisket as a resist, she is able to preserve tiny spots of pure white paper for the effect of glittering sunlight among darkly colored leaves.

Then she develops her dramatic darks with a series of washes. She points out that you can't have lights without darks; it is the contrast that gives each value power. "You must be brave to put those darks down. The worst that can happen is that you'll ruin it. It's just paper."

The hardest thing about painting for Cornell is to have a certain image in her mind or a feeling and not be able to make it happen on paper. She says, "Artists have a lot of failures, but I learn from every one. The amount of success is better than it was ten years ago. Still I'm never 100 percent satisfied. As you get better, you become more demanding. What keeps an artist going is the sense that the next one will be better. I do have some clinkers and anybody who says they don't—I'd like to meet them."

What does she do with the "clinkers"?

"I put them aside. I let a lot of time go by, maybe a year, and I rework them, experiment with them. In that time I might have learned to solve the problem. That's why it's important to use good paper. You can wash out and scrape out and that's fun too."

Each painting begins with a scene that strikes her eye. When she travels, she always takes a camera and a sketch pad with her. She takes at least seven or eight photos of the subject from different angles to capture the lighting and the details. She explains, "The photograph is a tool. I use it as a re-minder. It's the little things that give the flavor of a subject or a place. I paint very detailed things and I don't have such a good memory."

Next she does a couple of value studies in pencil to work out the composition. Then she draws the subject onto her watercolor paper. Her number-one advice to students is *learn to draw*. She says that drawing is the skeleton of the painting. She takes a figure-drawing class once a week to loosen up, like exercise for a dancer.

The pencil sketch is just a guide. She says, "When you're working with the color, you can get carried away and have to fly by the seat of your pants. I plan somewhat, but I always leave myself a lot of leeway. The nature of watercolor is such that if you plan too much, there is no life in it."

She uses excellent materials, explaining that when you put your heart and soul into something, you want to use the best materials you can. She experiments with a wide variety of brushes, but it comes down to whatever will work best, often just a sponge or an old worn-out brush.

Cornell says, "Painting looks like a lot of fun. It is fun, but you are also trying to say something. A lot of you goes into a painting. I get up every day and pinch myself, I'm so glad to be an artist, but it helps when people appreciate it. I love when someone says, 'I looked at that scene before, but I never really saw that before.'"

Patterns, Arlene Cornell, 20″ × 24″, Watercolor

This painting shows how Cornell uses the patterns of light and shadows to develop her compositions. By combining the geometric shapes of architectural detail with the lines of cast shadows, she has created a dynamic design that zigzags through the painting.

Demonstration: A Passion for Light

This is one of many drawings and photographs Arlene Cornell used as reference for *Stone Bridge*. What attracted her to this scene was the interplay of light and shadow dappled across the path in contrast to the dark stone bridge.

Step 1: First she executes a precise drawing on her watercolor paper. When she is satisfied with the drawing, she uses masking liquid to block out the areas she wants to save for the light shining through the foliage. After she has painted over these sections, she will remove the dried masking substance that has preserved the pure white of the paper.

Step 2: Usually she follows the traditional watercolor method of painting the light areas first, but she decides to start here with the dark bridge because it is the focus of the painting.

Step 3: She paints out from the bridge, developing the foliage and establishing a sense of the light source.

Stone Bridge
Arlene Cornell, 16″ × 20″, Watercolor
Cornell completes the painting with the pattern of light and shadows that originally attracted her to the subject.

Along the Road
Arlene Cornell, 20″ × 24″, Watercolor

Green Mansions
Arlene Cornell, 14″ × 20″, Watercolor

In choosing a subject, Cornell looks for light falling on specific shapes in nature and architecture. To capture the details she uses photos for reference material.

Reflections
Arlene Cornell, 19″ × 26″, Watercolor
Cornell says this painting contains all the elements she loves to paint: water, sky and old houses. The reflections in the water give her an opportunity to juxtapose abstract patterns against the well-defined details of the architecture.

Winter
Arlene Cornell, 15″ × 21″, Watercolor
This painting is a study in value contrasts. The dark patterns of the bare trees oppose the bright white of the snow-covered fields. In the middle of the value scale are the grays of distant foliage.

Painting Glorious Light

In northern California, early-morning light is crisp and bright and the shadows are sharp and dramatic," says Gil Dellinger. "There is a first-of-the-day glow like the world is being reborn. The colors are acidy yellows, sharp and crisp greens. The light starts to flatten by ten and by noon it is completely flat. As day goes on the light becomes redder and oranger. By the end of the day the shadows are red. The greens are touched with red rather than the yellow of the morning.

"It changes a little bit in the winter because the light is always from the south. It has a golden cast all day long. Somewhere in mid-August the light begins to change, turning brown and warm, and I can tell fall is coming. The best light is in October and February, sometimes in January. I can tell the time of the day and the time of the year in a painting depending on the accuracy of the artist."

Dellinger himself is one of those artists whose work tells you exactly when the light is occurring. In fact, that's what he says he is painting, the light as it moves across majestic mountains and beaches. However, he wasn't always a landscape artist. He says his first work was of human figures and historical subjects, much more concerned with detail than light and mood.

He had seen a book on Vermeer and knew that was what he wanted to capture, the light, color and serenity, "the isolation of grandeur in simple things." Unfortunately he had no idea how to do that and for fifteen years he saw results that didn't even come close to his vision.

Then in the mid-1980s he made two discoveries that changed the course of his art. The first was learning to see, really see, the landscape around him. Although he had lived in northern California for years, it was only then that he began to notice the intriguing patterns of light and color in the surrounding farmlands. The second discovery was the joy and freedom of working with pastels. The richness of color and immediacy of pastel allowed him to develop a style of painting that he now uses with both pastel and acrylic.

His paintings begin with watching the landscape. He sits for hours studying the patterns of color and value as the light moves across the landscape. He says that often he sits for a whole afternoon without shooting a single photograph. Although he paints from slides, he says that 90 percent of the work is actually remembering.

He starts a painting by laying in the shadows. He says, "I use the shadows for directional flow, to break up the space or for emphasis. The shadows also help establish spatial depth. If the shadows sit well, with the value changes going back in space being consistent, then the space will be believable. Contrast of light and shadow are always more extreme in the foreground."

Once the shadows are in place, he turns to color. His main consideration in developing color is also showing the mood of the light. He builds the color in layers. He says,

"I might underpaint a whole stand of trees red and you might not see it in the finished painting except as little sparkles of red showing through. I just painted an orchard where I came over the top with an English red in glazes and scumbles. That red wasn't really there at all, but by adding the red I made the painting look like the green orchard in late afternoon sun."

Dellinger says, "Between the initial conception and the completion of the piece is a lot of hard work. There is that tedious stretch. That's where the discipline comes in. The difference between success and failure is the courage to keep going. You have to have faith that it will work."

What makes a painting successful to him is the mood that it conveys, the mood projected by the light. It always comes back to the quality of the light.

"Summer light is very soft; outlines of things are soft. There might be a lot of dust in the atmosphere. Winter light is soft in a different way. The angle is so sharp that nothing is very defined. When there has been a storm in the winter, there will be a short period of intense golden light, maybe ten or fifteen minutes.

"You can learn these things only by watching," Dellinger says. "The most important function of the artist is to be an observer for everybody. Artists need to get out and see things, really see things. God expects us to go out and look at what He's done."

He concludes, "You can't expect

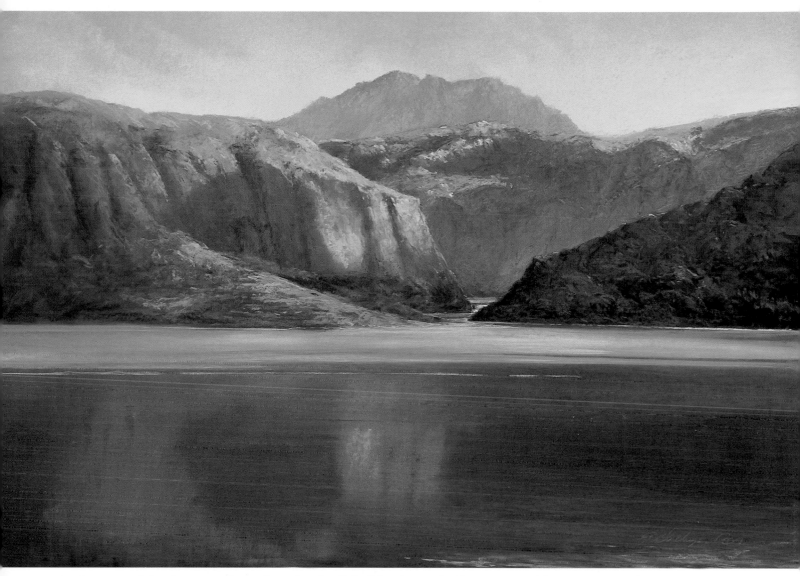

to be a good landscape painter in two or three tries. There have to be a lot of mistakes. There have to be a lot of failures. It takes years and years and years to learn a subject. I don't think you can paint with passion if you're jumping all over the block.

"The artist always wonders, Am I doing anything? Am I saying anything? There are superficial paintings of subjects and deep, profound paintings of the same subject. It depends on your intent and knowledge. It's a matter of commitment."

Apache Calm/Morning in the Superstitions, Gil Dellinger, 27″ × 40″, Pastel
One of the more interesting aspects of light is the way reflected light picks up the colors of the surrounding environment. Dellinger uses reflected color to create a dynamic abstract design in the foreground water.

Demonstration: A Passion for the Moment

Step 1: Gil Dellinger begins to develop the colors of crisp early morning light with loose strokes to mark the main shapes in the painting. The pink and violet areas will be an underpainting to warm up the light on the rocks.

Step 2: He begins to blend and tighten the masses of color. From the beginning he has been establishing the light and shadowed areas, which he says are the foundation of any composition. Here they become well defined.

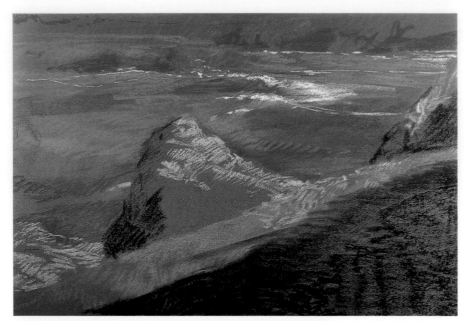

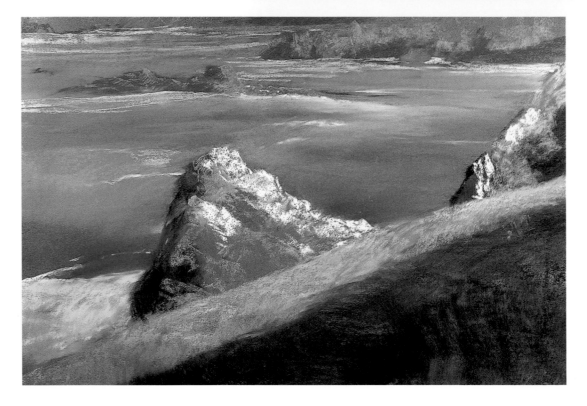

Step 3: He develops the curving patterns of white foam on the water and refines the green areas.

Big Sur/Winter Light
Gil Dellinger, 18″ × 27″, Pastel
The final step is creating surface texture in the foreground. He does this with un-blended strokes of warm against cool colors in the grass and rock areas. Besides contrast of colors, he also contrasts the mosaic-like strokes of color in the foreground against the smoother application of paint in the water.

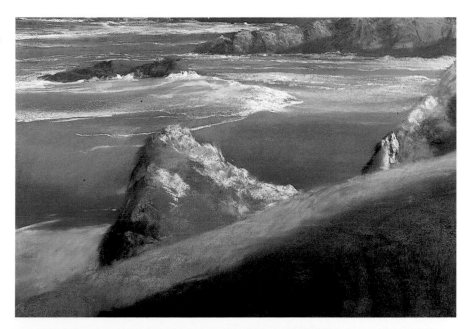

Thunder
Gil Dellinger, 12″ × 18″, Pastel
Dellinger's paintings are studies of light and shadow. Here the composition is totally defined by the value changes of light and shadow falling across the cliffs and clouds.

Winter Hay In
Gil Dellinger, 32″ × 48″, Pastel
This would be a very simple composition — the diagonal line of the fences receding to meet the horizontal shape of the farm and trees — but the strong shadow in the foreground adds another dramatic element to it.

Ancients in the Mist
Gil Dellinger, 20″ × 30″, Pastel
Dellinger loves to show the atmosphere of a scene as well as the light. He helps convey the feel of mist by softening edges and details in the distance, graying the distant colors and reducing the value contrast.

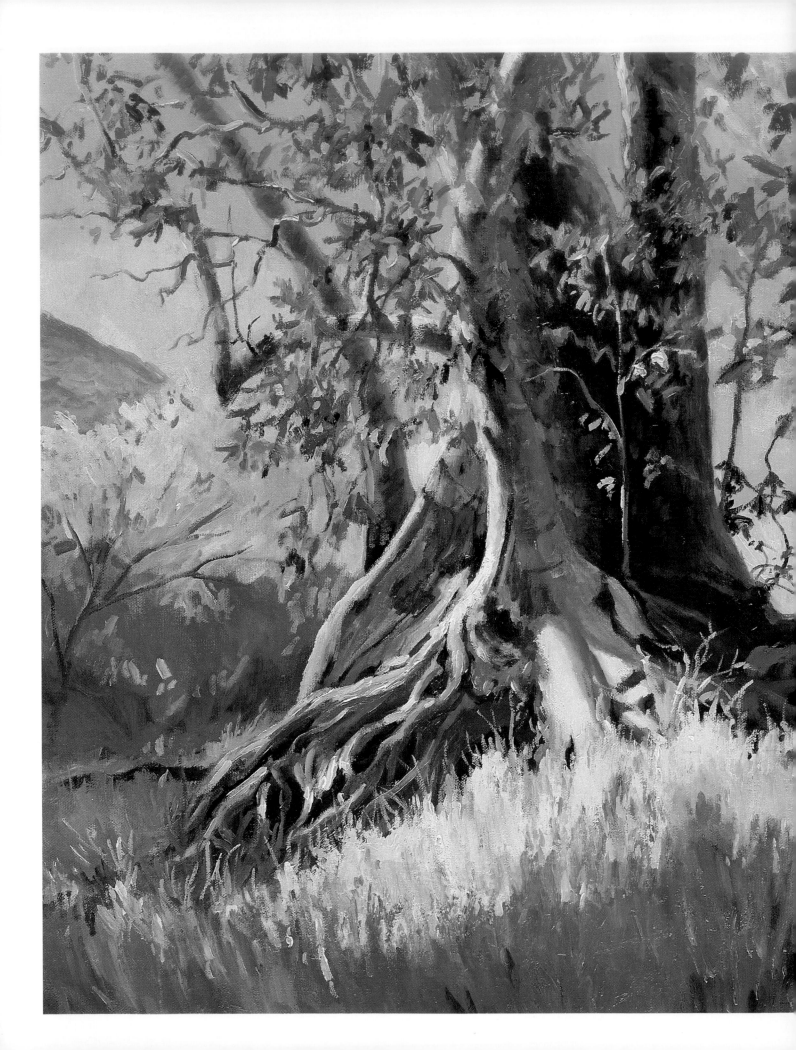

FOUR

PUTTING THE PIECES TOGETHER

Some kids are fascinated with how things fit together. They spend their childhood taking toys apart and then trying to get all the pieces back together again. There are artists like that too, looking at all the abstract components of a scene and then assembling them into an artistic composition. Instead of Tinkertoys, they are playing with shapes and colors and values.

There are always compositional choices to be made by an artist. Even if you precisely reproduce the scenes that appear before you in nature, you must still decide how much of the scene and which part of it to include in your painting.

Although the process of planning a composition might seem like a cold, intellectual process, this is actually one of your greatest sources for putting passionate expression into your paintings. The amount of balance or imbalance, the movement or rhythm through the painting, the placement of the focal point—these are the components that determine the dramatic impact of your finished piece. For some artists, planning the design is the most compelling part of the painting process.

The secret to successful composition is looking at your subject in terms of its abstract components. A tree is not a tree. It's a shape with color and value. The horizon line is not where the sky meets the ground, but the division between the upper mass and the lower mass.

For many artists it helps to start with small compositional studies where you graphically divide the image into simple shapes of value or color. In this smaller, more abstract format, it is easier to move elements around, to play and experiment, until you find the most visually compelling design.

Two qualities must be present in any successful composition: *balance* and *contrast*. A composition is balanced when all the elements sit comfortably within the format. For every shape, color or value in one section of the painting, there is a shape, color or value to balance it in the opposing section.

What keeps the design from being too restful or boring is contrast. The artist provides a variety of shapes, a variety of colors and a variety of values within the image. The more extreme the contrasts, the more dramatic the composition.

To make the composition more dynamic you can add *tension* and *movement*. Tension seems to be the opposite of balance, but it is possible to have both qualities in the composition. For instance, I have a small dark shape on the right side of a painting. If I add a small dark shape on the left side, the painting will be exactly balanced. If I have a small dark shape on the right and add a larger dark shape to the left side, that side will be heavier and that will add tension to the piece. It becomes more interesting to look at. Of course, too much tension will make the design unbalanced and looking at it will be uncomfortable.

Movement refers to the path of the viewer's eye through the painting. A strong *focal point* will catch the viewer's eye. This can be a spot that is interesting because of the subject, the lighting or color. Often the focal point is that place in the painting with the greatest contrast, like a bright spot in a dark background.

To keep your viewer interested in the painting, you want to move the eye from the focal point to another place in the painting. This can be done by creating secondary focal points or by placing lines or directional shapes leading from the focal point to another center of interest.

Since there are two kinds of space in a painting, two-dimensional and three-dimensional, you can move the viewer's eye in two ways. You can move the eye on the surface of the picture or you can move the eye into the spatial depth of the piece. A good technique for doing that is to place a path or other receding shape within the composition. The eye automatically follows that path.

I teach my students that people are lazy. No one really wants to look at anything if they don't have to. Your job as an artist is to force the viewer to look at your painting and to keep looking at it. You can do that simply by mastering dynamic composition.

Bird's Nest Study
Henry Casselli, 15 ½″ × 20″, Watercolor
Casselli often takes one compositional element and experiments with different placements in a variety of paintings. The large white wooden beam that figures so prominently in his "Bird's Nest" series creates an arrow shape that helps focus the viewer on the figure. Casselli darkened the outer ends of the beam so they wouldn't draw the viewer's eye out of the composition. Notice that the angle of the arm reflects the angles of the beam.

Eucalyptus II
Norma Auer Adams, 40″ × 60″, Acrylic
In planning a composition, the negative space is equally as important as the positive space. Look at the blue shapes that occur in the background of this painting; even without the leaves they would create an interesting pattern.

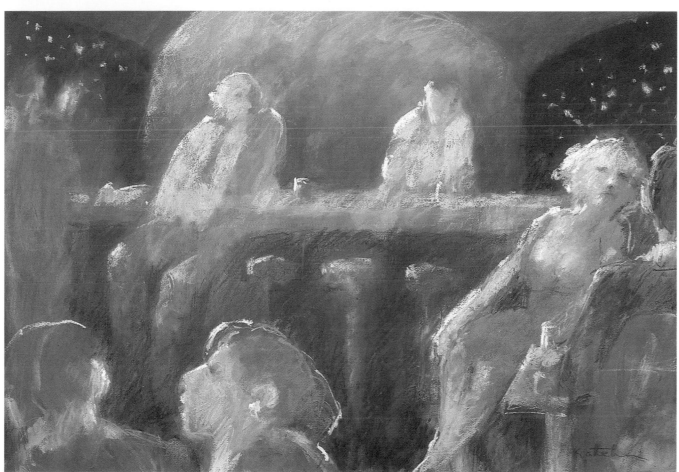

Across a Crowded Room, Carole Katchen, 27″ × 39″, Pastel
One of the more challenging subjects to compose is a group of figures scattered throughout the painting. Here I unified the design with a circular arrangement of the figures. The woman in the pink dress leads the eye down to the heads in the left foreground. The light values pull the eye up to the figure on the barstool, to the bartender, and then back to the woman in pink.

Demonstration:

Step 1: Joe Anna Arnett begins by marking the triangular shape of the subject onto her toned canvas.

Step 2: She masses in the objects of the still life as one large shape.

Step 3: She starts to develop the individual elements and blocks in the negative space, which reinforces the central shape.

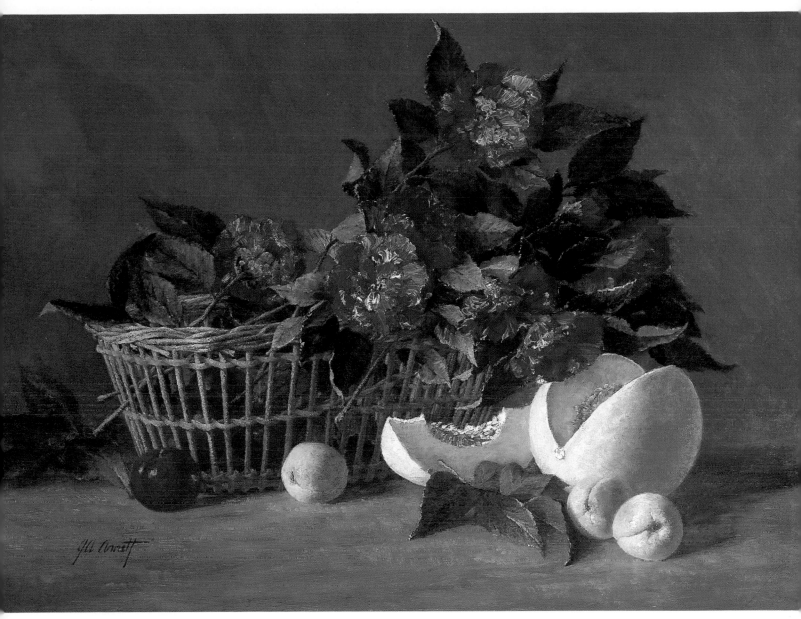

Camellias
Joe Anna Arnett, 18″ × 24″, Oil
In the finished work you can see how the underlying triangular shape adds unity to the group of objects that comprise the still life.

The Shape of Space

Some artists have trouble seeing the abstract shapes of the various parts of a composition. A good way to clarify the shape of something is to see the negative space, what is around it.

Set up an object with an interesting shape. Place it on a table with a simple background and no other objects around it. On a piece of paper, solidly draw or paint in all the space *outside* of that object. Be very precise about the contours that divide the object from the negative space. You will end up with a light silhouette of the object and a dark background.

This is very helpful if you are having trouble seeing the shape of a group of objects, like a bouquet of flowers. It is much easier to develop your composition if you think of them as one large shape and plan the negative space around that.

Source photo for "Spires for Stephen"
William Vrscak

Spires for Stephen
William Vrscak, 22″ × 30″, Watercolor

The illustrations on this and the facing page show how William Vrscak takes a source photograph and alters the basic shapes and values to create a more compelling composition. In *Spires for Stephen* he cropped in close on the rooftops so that he could emphasize the architectural details. He left the wires in the composition for more visual tension.

In *House on Antrim Street* he made the building smaller, but made it white to give it more impact. He widened the street on the right and removed a telephone pole so that he could emphasize the curve of the intersection.

Source photo for "House on Antrim Street"
William Vrscak

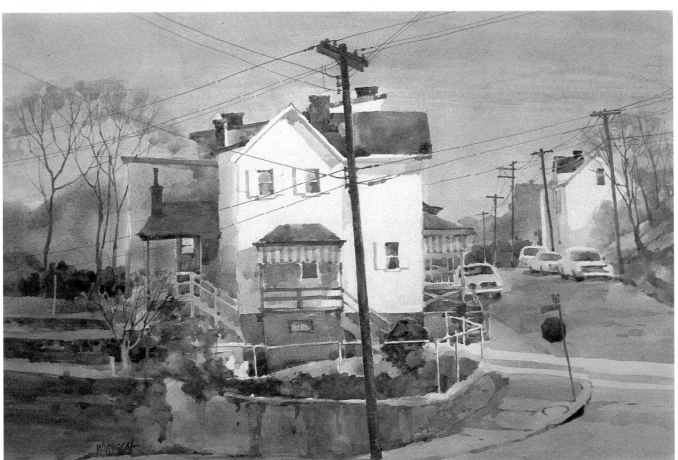

House on Antrim Street, William Vrscak, 15″ × 22″, Watercolor

The Design of Obsessions

John Dobbs is an Expressionist. He explains, "Art for me is not separate from my life; it is very much an expression of what I feel. I try to be as unconscious as possible and go with my obsessions."

He says he usually gets an idea from seeing something. It's not the thing itself that he wants to paint, but his reaction to it. He often works from "fairly banal" subject matter—buildings, subways, streets, railroad tracks—and uses those as a vehicle for expressing what he has observed about life.

"Perhaps I have a contrary nature," he says, "but even during the 1950s and 1960s, before a time when words like growth, progress and development made one wince, I was involved with seeing another side of things. Collapsing buildings, cars rotting away in overgrown fields, abandoned houses and homeless people kept cropping up in my images."

He is not interested in precise realism, although his imagery is usually clearly defined. His paintings are filled with metaphor and symbolism, but he explains that he doesn't start with metaphor; that is something he arrives at during the course of painting. On the first level, it's always a painting of the thing.

Composition is vital to Dobbs to convey the meaning of those "banal" subjects he is painting. Where he places the objects and figures, the arrangement of light and shadow, the use of perspective— these are his tools for expression.

Often he paints the same subject over and over in different compositions, looking for the most powerful statement.

His application of paint is bold and intuitive, varying with every subject. He says,"I like complicated paint surfaces. Sometimes I get an image down too quick and it doesn't have enough substance for me. I want you to be able to go back again and again and see something new."

Dobbs grew up in a family of artists, surrounded by art, music and books. In 1949 he went to the Rhode Island School of Design, where he lasted for only six months. The classes there were concerned with design, and specifically Bauhaus principles of design. He was much more interested in the Social Realists and German Expressionists. So he designed his own education. He enrolled in classes at the Brooklyn Museum with Max Beckmann and Ben Shahn. He haunted galleries and museums. He knocked on doors of artists he admired like Raphael and Moses Soyer.

He says it's difficult for him to describe his own painting methods exactly. He explains, "I work on a number of paintings at the same time. I've always envied painters who do them one at a time; it's a lot tidier. I sometimes have as many as twenty unfinished pieces propped against the walls and on the four easels in my studio.

"I start a painting when an idea comes to me so I won't forget it. Sometimes I will push ahead and finish it right off; at other times a painting can sit around for three or four years sporadically being worked on. I try to set the larger elements of the composition and some sort of light and dark scheme. Sometimes things never look better than after the first hour and you work for the next four and one-half months trying to get back to that."

When he sees an interesting subject, he'll record it in sketches and photos, perhaps a quick oil painting, often monochromatic, just to get the composition down. Capturing his initial feeling about the subject is crucial.

"I spent a summer in Europe," he relates. "I told a friend I hadn't done any work and then I realized I had filled two or three sketchbooks. Somehow I don't think of thinking and drawing as work.

"Sometimes I'll go back to my sketchbooks for figures or ideas. I work from memory a lot. I'll try to memorize a site, particularly in terms of light. The problem with photographs is you tend to get locked into something because it's there. I use photos just as a reference for construction. I want to be free to invent.

"I paint with knives and my fingers and rags a lot. In the heat of the moment, I will use whatever is around and will get the job done."

He considers a painting successful when he has gotten the idea down with an intriguing surface and not too much detail. He doesn't like to feel that he is rendering things; he wants to put them down with broad strokes that express more passion.

Rusted Rails, John Dobbs, 36″ × 26″, Oil

Dobbs designed his composition in a preliminary pencil sketch, then executed the painting in oil. The format is basically divided into horizontal bands across the canvas. He breaks up the horizontal monotony by placing the house in the upper left and disrupting the red and white rail in the lower right.

Demonstration: A Passion for Exploring a Subject

In this group of studies and paintings you can see how John Dobbs explores a subject—in this case, a subway platform. He repeats the basic image over and over, altering composition, value and color. The common element in all these compositions is the emphasis on linear perspective, which Dobbs says is a metaphor for linear time.

Subway Study
John Dobbs, 9″ × 12″, Pencil

Platform (Above)
John Dobbs, 7″ × 10″, Oil on panel

Platform #5 (Right)
John Dobbs, 36″ × 52″, Oil on linen

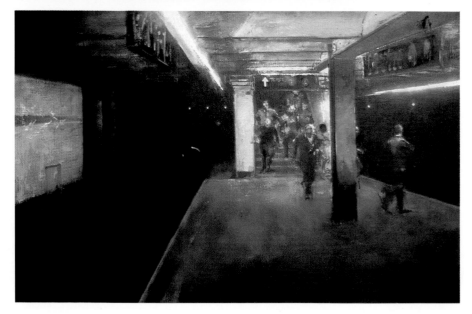

Subway Platform
John Dobbs, 22″ × 20″, Oil on linen

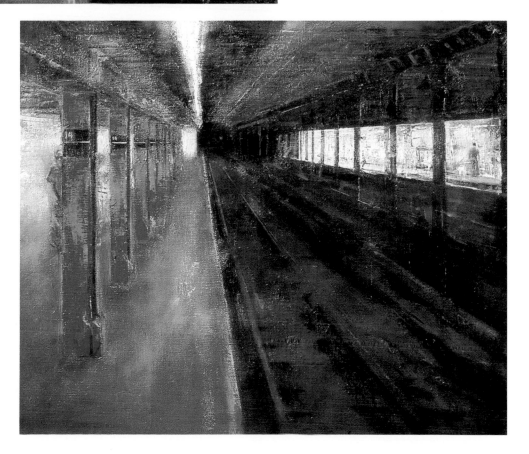

Subway Platform #2
John Dobbs, 30″ × 36″,
Oil on linen

Putting the Figure in the Picture

I don't have a great mission," says Henry Casselli. "I paint the people and things and associations of my world, all the gumbo of my life. There's no social statement. I'm not fighting for any causes. When people look at my paintings, they always think there's some deep story, some deep message. I tell them it's in their hands now."

It's because of the dramatic subjects and the sensitive execution of the images Casselli paints that people expect a deep meaning. The only message in this Louisiana artist's work is a profound love and respect for the world around him and the love of being an artist.

His paintings, mostly watercolors, begin with either the model or an idea for the composition. The series of paintings that includes *Bird's Nest Study* (see page 74) began with the large white beam. He explains, "The idea had been there for a long time. That white beam against the dark barn was echoing in my mind. Then I saw that big white beam with the dark person standing against it. It was stunning."

The models are always special people to him, never chosen just for how they look, but always for who they are. He says, "I don't bend and push the model like a mannequin. I do many paintings of a model, putting myself aside. I had an idea for a painting of a girl and a seashell. I've done seventy paintings of her so far and still haven't painted her with the seashell. I'm still getting to know her."

The painting starts with the drawing. He says sometimes it is very loose so as not to inhibit the spreading of paint. At other times, when the subject matter is more involved and he feels more need for correctness of anatomy, proportions, etc., then the drawing is more complete. When the drawing is in place, he lightens it with a kneaded eraser so that it won't interfere with the painting.

"As the drawing builds, there is a great deal of time and thought given to the placement of subject matter in regards to what it adds to the composition and the meaning of the work. While one's idea or original concept may exist in the mind's eye in 3-D and full color, it rarely translates to the two-dimensional surface without much change."

He cautions, "You want to plan, but you don't want to overplan. You want to leave room for the adventure or you're only a craftsman filling in the color between the lines."

Unlike many watercolorists, Casselli does not have a strict rule about when to lay down the lights and darks. He explains that with watercolor you have to be about six brushstrokes ahead of yourself. There are some lights that you must leave in the paper, for instance, for the edges where darks meet light or blend into light; others can be added later with opaque paint or by scratching or sanding the painted surface.

Sometimes, he starts by slowly building up the light values. However, there are times when he jumps right in with the darks, knowing that he can always come back and reestablish the whites later.

He has learned that when he starts with the darks, he has to start and work right through the whole dark passage. He sticks the brush into his dark paint and mops it on. If he lets a dark dry, then when he goes back and paints over it, he gets bad edges, bleeding and shiny spots.

He uses any technique that will work to get the value and the effect that he needs. He says he has walked on paintings, smeared his foot on them, and used his fingerprints to get a desired texture. To get white highlights in a dark area he may scrape it with his fingernails while the paper is still wet. After the paint is dry, he'll gouge into the paper with razor blades, nails and sandpaper. He'll peel up the surface of the paper or sand it with his Black & Decker sander.

Casselli, whose portrait commissions have included an official portrait of then-president Ronald Reagan, says that portraits are the most draining emotionally and physically of all the work he does. His research generally includes many visits and long hours of discussion, an exhaustive journal of detailed word sketches, some rough drawings and some photo sketches.

He says, "A portrait must be a painting first and must be built upon all of those things that my other works represent—a personal response, a deep emotional connection, an understanding of the subject matter, and a reason to do the painting, which becomes known only after the artist and subject become part of each other."

Larissa, Henry Casselli, 52″ × 34″, Watercolor
In his figure paintings, Casselli strives for more than just a physical likeness. He is seeking a deeper emotional truth about the person as well as his own response to the model and the situation.

Demonstration: A Passion for Emotional Connection

Step 1: Because this is such a detailed image, Henry Casselli did a very complete, precise underdrawing in pencil. Before applying paint, he lightened the pencil lines with a kneaded eraser.

Step 2: He begins the painting with the head, which is his center of interest, and he gradually works out from there. He establishes the dark hair early as a dark value against which to judge all the subsequent values.

Step 3: As he develops the background and the girl's dress, he begins to feel that there is something wrong with the composition. He considers adding another figure.

Step 4: He decides against the additional figure — that would complicate the composition too much, but he adds some sheet music at the girl's feet and removes the watering can from the lower left.

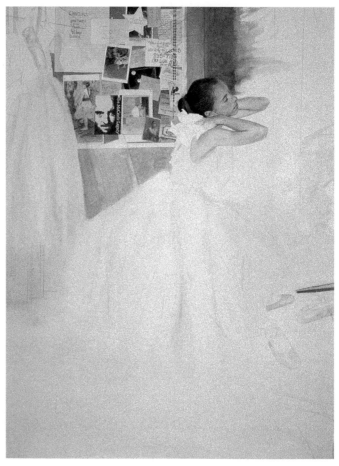

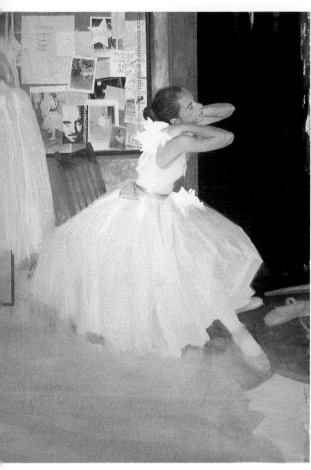

Veronica's Birthday, Henry Casselli, 29″ × 21″, Watermedia

He resolves the painting by simplifying color and composition. The floor becomes a cool gray that merges with the dark area of the background. The warm browns of the chair and wall are eliminated with opaque paint and that whole area, the girl, light wall and hanging dress become one pinkish shape. The composition now is composed of two shapes, a dark cool mass and a light warm mass. This simplicity allows the figure to resume her importance in the painting.

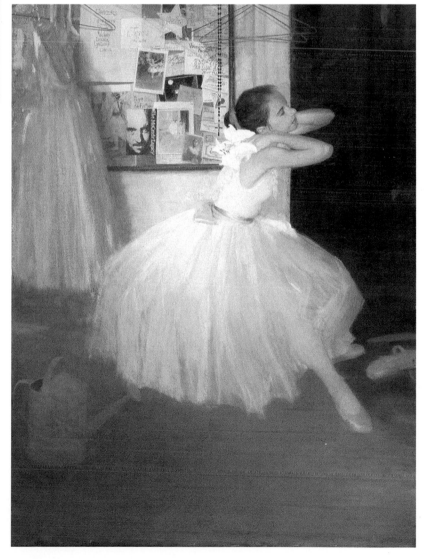

Composing Beauty

Martha Saudek, who lives in Los Angeles, a city of fifteen million people, says, "I love to paint scenes of the countryside that appear to be undisturbed by man. Thus my paintings will usually not contain people, houses, bridges, fences, roads, etc. It is a joy for me to be away from the city, surrounded by the beauty of nature. My spirits soar and it is that feeling I want in some small way to share with others. I find my rural outings to be nurturing to my inner self and if others can also be uplifted, then my paintings will have met their purpose."

Saudek came to art late in her life. She didn't start to paint until after she retired from a long and successful career as an elementary school teacher and administrator. She says she didn't decide to become a professional artist; it just happened.

It was from Hal Reed, her long-time teacher and mentor, that Saudek learned many of the principles of composition that she uses in every painting—dynamic division of space and value, placement of a focal point, use of a dominant hue and complements. Although her inspiration is the beauty of nature, the foundation of her paintings is precise, well-thought-out design.

Saudek's paintings begin with small, black-and-white composition studies or "comps." Even when she is painting small oil studies on location, she still takes the time to sketch the design before she starts painting. Composition is primary and she feels no hesitation about moving a tree or a mountain range to make the design more pleasing.

In these first studies she arranges the main shapes and the lights and darks, indicating the subtle clues of reflected light as well as the more obvious values. She strives for *dynamic* composition, so she never divides the format in half by placing the horizon line at the center. The focal point never goes in the exact middle. Diagonal shapes and lines are emphasized.

She explains, "I'm always looking for strong diagonal lines to lend dynamic action to the painting. It could be a stream, a row of trees, a path of light. A horizontal is much more peaceful, and, yes, I do like to paint serene scenes, but within that serenity, I like a sense of action."

Saudek plans how the viewer's eye will move around the canvas. She starts with the focal point, the place where your eye enters the painting. The focal point and secondary points of visual interest are located in the beginning and defined during the painting process. They might be emphasized by thicker paint, strong contrast of dark against light, juxtaposition of complementary colors, or precise rendering of detail.

By the time she is ready to start the canvas, she has planned her values. She uses a system she learned from Reed for dividing values. There will always be dark, midtone and light in different proportions. She says to think of it as if you had a gallon, a quart and a pint. There will be a dominant value (the gallon), a secondary value (quart), and a value for accents (pint). The dominant can be dark, medium or light. If it is dark, for instance, then the secondary will be either medium or light. The smallest value will be whichever one is left over.

Before starting the painting she has also planned her colors in a broad way. She selects a dominant hue; then decides if the painting will be monochromatic, if it will contain complementaries, or if it will contain complementaries and discords.

She tones her canvas by applying small amounts of color onto the canvas with a palette knife and then smearing the paint lightly over the canvas with a turpentine-soaked paper towel.

She says, "It's a lot of fun to leave some of the underpainting showing through. Raw sienna is a good underpainting color. Once I underpainted a rock with raw sienna. I went over the light side with a warm white and the shadowed side with grays. I left the edge unpainted and the raw sienna showing through looked just like sun shining on the edge of a rock."

She begins painting the dark areas first, then the middle tones and the lights. She works with broad strokes of thin paint at this stage. When the whole composition is blocked in, she turns the painting upside down or looks at it in the mirror to assess the basic color and value design.

Once any necessary changes are made, she refines tone and color with thicker strokes of paint, focus-

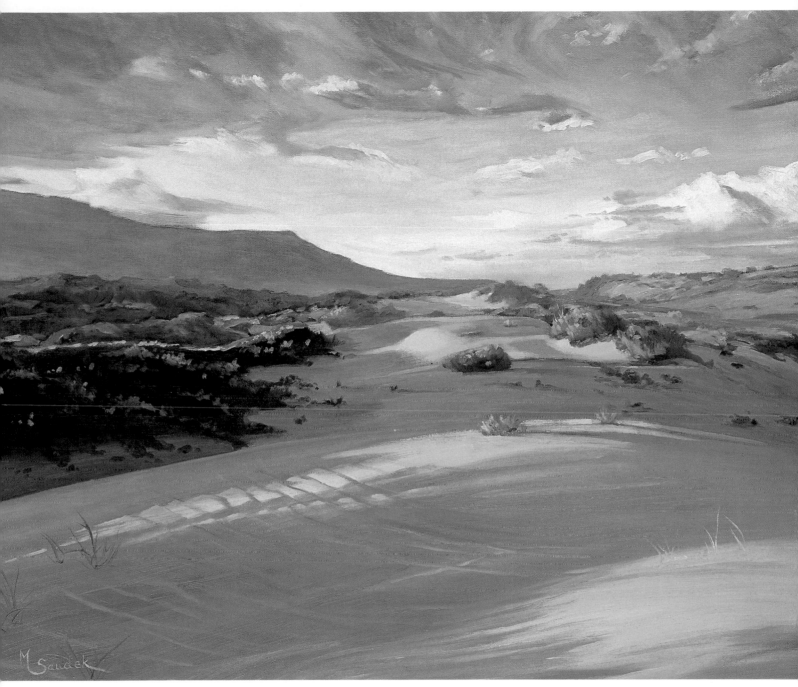

ing now on direction of light, three-dimensional form, and relationships of warm and cool colors. She says, "I don't want to put in too much detail as I like to leave something to the viewer's imagination."

When this phase is complete, she lets the painting sit for several days. By that time she can view the piece more critically. Now she adds the final highlights and darkest accents. She signs the piece and sprays on a coat of damar varnish.

In Saudek's relatively short career, she has won more than one hundred national and regional awards and been included in shows from Taiwan to New York. Sometimes she muses about how different her life would have been if she had taken up art earlier, but mostly she is just curious to see how it is all going to turn out.

Desert Spring
Martha Saudek, 26″ × 32″, Oil
Here you see how light and shadow can be used to break up the space and provide visual movement into the composition. The viewer's eye moves from one patch of warm sunlight to another, back into the distance.

Demonstration: A Passion for Natural Beauty

Step 1: Martha Saudek begins each painting with a number of sketches to decide the most effective composition.

Step 2: With paint she draws a general indication of the spatial divisions and proportions. Then she loosely brushes in just enough color to verify that the overall composition will be pleasing.

Step 3: She continues to mass in the large areas with smooth strokes of color.

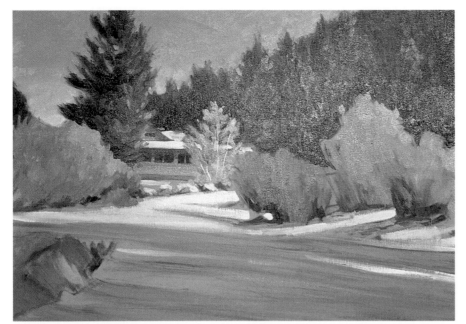

Step 4: Once she is satisfied that the basic shapes are in place, she begins to suggest detail by using more distinct strokes of color.

Winter Morning
Martha Saudek, 18″ × 24″, Oil
The final step is adjusting color and value. Middle values are dominant in this composition, with a smaller amount of light values and just a few accents of strong darks.

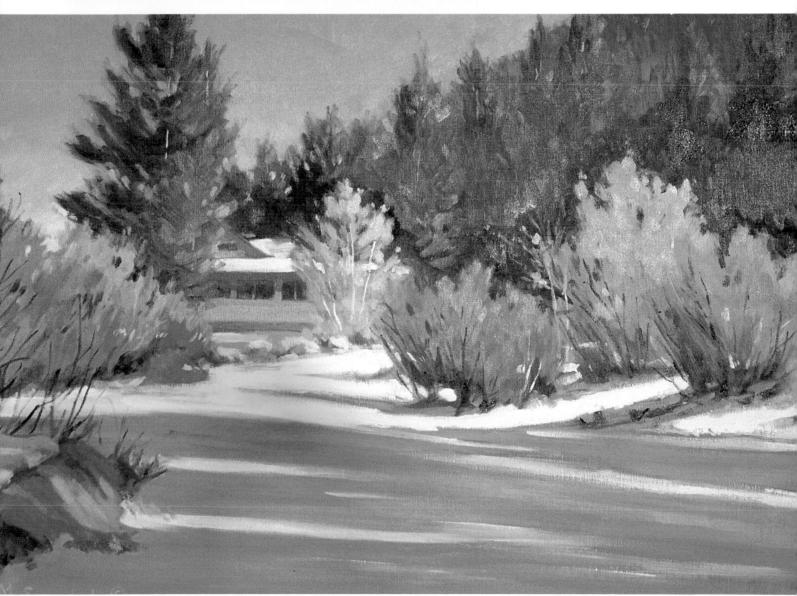

Oasis
Martha Saudek, 22″ × 28″, Oil
This painting shows how Saudek composes with color. Because the dominant hue of the painting is blue, the pattern of complementary orange accents keeps the eye moving through the painting.

El Viejo
Martha Saudek, 24″ × 36″, Oil
How you crop the subject makes a big difference to the composition. Saudek includes only part of this tree in her composition so that the branches will divide the negative space into interesting shapes.

Miles To Go
Martha Saudek, 24″×36″, Oil
A receding road or river is an excellent way
to draw the viewer's eye into the spatial
depth of a painting. The sense of distance
is reinforced by decreasing value contrast
and detail.

MAKING YOUR MARK

The individual strokes of color on paper or canvas are the artist's handwriting and, like handwriting, they say a great deal about who the artist is. Some paint application is bold and aggressive; some is soft and refined. Some artists deliberately plan the kind of stroke and texture they want their finished work to have, but with most artists the stroke, like the overall style, naturally evolves.

Artists can have vastly different attitudes about surface texture, the way the pigment sits on the paper or canvas. Some of them want the individual strokes to show so that the viewer can know how the paint was applied and feel like they are part of the process. Others want a totally smooth surface so that nothing will detract from the image.

In my own work I sometimes feel schizoid in regard to surface texture. Working in pastel the choices are infinite, depending on the hardness of the chalk, the texture of the paper, and whether or not I blend. Some of my paintings have a totally smooth surface; some look like a tapestry of individual strokes; and some combine a variety of strokes and textures. It depends on the subject and the mood I am trying to evoke.

Most artists begin to develop their sense of stroke when they start to draw. With their first marks of charcoal on paper, they are developing that "handwriting." No two artists draw a line the same way. Heavy or light, tentative or bold, solid or broken, such a simple thing as a straight line expresses the artist's personality and aesthetic choices.

There are artists who love lines. They are passionate about the calligraphy of a gesture line or contour line. The line gets thicker and thinner, lighter and darker with sensual curves or jagged angles. Even if there is no subject, the line itself is a source of fascination for the artist and the viewer.

Other artists have no particular interest in lines except as a way of defining shapes.

However, it is important to know that lines and strokes of color have a profound effect on the expressiveness of a painting. A viewer is affected by the way you put your paint on the canvas; so if you want to control the kind of impact your painting makes, you should be aware of line quality, stroke and surface texture.

When I teach a workshop, I ex-pose the participants to a wide variety of strokes and textures. As with all other aspects of art, the more you know, the more power you have. Whenever possible, I insist that the students stand at an easel so that they can use their whole arm and upper body to draw and paint. When you move your pencil or brush only from the wrist, you are restricted to a tight, small gesture.

I teach my students to put down bold, individual strokes and then to blend them together, noticing the different impact the various surface textures have. I make them wipe the pigment off the surface, leaving only a ghost image of their strokes so that they can see the impact of subtle color and value changes.

No matter what medium you use, the possibilities for expressive stroke and texture are enormous.

Monterrey, Arlene Cornell, 20″ × 24″, Watercolor
Watercolorists must be very deliberate about their brushwork because each stroke is obvious. Cornell created the feel of water with narrow, parallel strokes in the foreground. For the smooth expanse of sky she used washes.

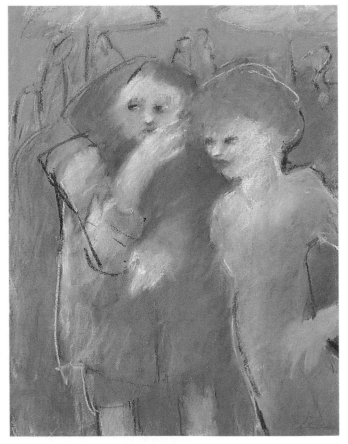

The Latest News, Carole Katchen, 24″ × 18″, Pastel
In many of my paintings I eliminate all of the definite lines, but I left the lines here because they have a spontaneous, vital quality. Well-drawn lines can add tremendous energy to a painting.

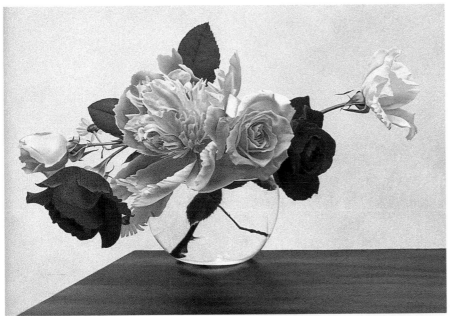

Phyllis's Flowers
David Hunt, 16" × 20", Oil
By blending strokes together and minimizing surface texture, Hunt emphasizes the effect of light glowing on the smooth flower petals.

Gracie
Kay Polk, 19½" × 14", Pastel
Polk begins the painting by blocking in shapes with loose strokes of color. In some areas, the background here, she then blends the colors for a smoother surface. In other areas she simply keeps adding new strokes of pastel until the colors become dense and appear to be smooth from a distance.

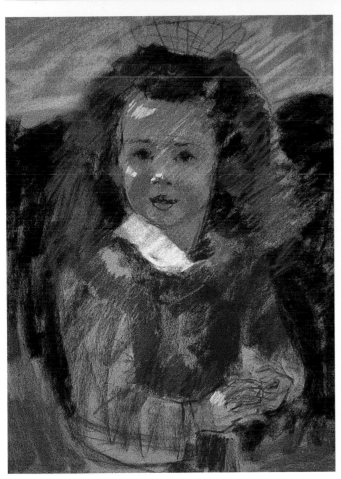

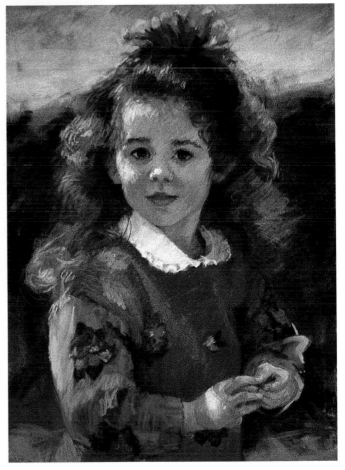

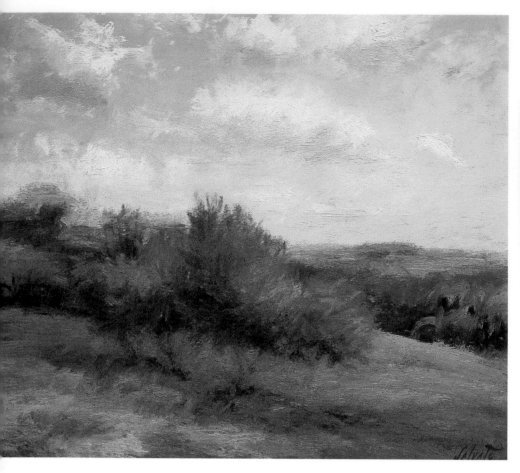

Summer Sketch at the Schuler Estate
Philip Salvato, 16" × 24", Oil
In this painting you can see how Salvato layers strokes of thick paint to build up subtle nuances of color as well as an intriguing surface texture. In the detail above, you can see how he uses the technique of scumbling, pulling fairly thick paint over the surface of already-dried strokes of a different color.

A New Line

The lines and strokes of your paintings add to or detract from the vitality of the finished piece. How can you get more spirit and creativity in your lines? William Vrscak suggests setting a timer while you draw.

Take a pair of shoes, the older the better, because those seem to have the most personality. Place them on a table or model stand where you can easily see them. Have several sheets of paper and a pencil or other drawing implement handy. Now set a kitchen timer to thirty seconds (one minute if the timer doesn't go that low) and draw the shoes in thirty seconds. When the timer rings, stop. Repeat the quick drawing exercise several times, stopping exactly when the timer sounds.

Next, do a thirty-second drawing. Then set the timer for a one-minute drawing, two minutes, three, four and five. Make each drawing as complete as you can within that time. Notice how much detail you can capture in five minutes. Then set the timer for four minutes. Do a four-, three-, two- and one-minute drawing. Finish with another thirty-second drawing.

For more line variety you can change from a pencil to a pen, brush, or other unfamiliar drawing tool.

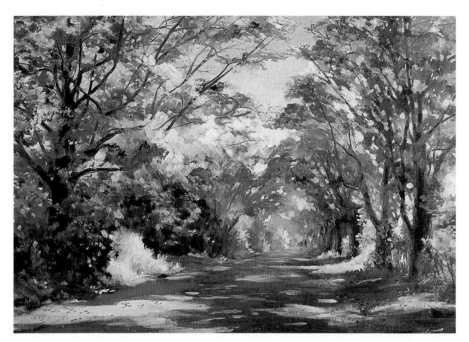

October Glory
Martha Saudek, 24″ × 36″, Oil
This foliage was created by the placement of many small strokes of color. Saudek doesn't try to paint every leaf, but just enough to give the impression of leaves. The more diffused area of cast shadows is done with larger, more blended strokes.

Pier 48
John Dobbs, 52″ × 48″, Oil
Dobbs is a master at creating atmosphere with his paint strokes. The soft, undefined paint in the background creates shapes glimpsed through the mist. The sharp, angular strokes in the foreground give an aggressive, almost violent movement to the pier, as if it is falling down as we watch.

Look at the wide variety of brushes available for oil or watercolor. Each brush makes its own kind of mark. And not just one. Each brush makes a variety of marks depending on how much paint it holds, the liquidity of the paint, how much pressure you use, and the length, speed and direction of the stroke.

Many of the artists in this book talk about painting with their hands, sponges, rags, whatever is available. Others work only with a specific tool for a specific effect.

The medium that seems to most encourage experimentation in texture is watercolor. Watercolorists splatter, drop salt or sand, float pigment, apply tissue paper—anything and everything that will produce an interesting texture. It is with watercolor that the danger of overusing texture becomes most apparent, but the same danger exists with every medium. Whenever the strokes or texture become so obvious that they intrude into the viewing of the piece, they will detract from the image. This is not necessarily bad. Texture has a power of its own (look at van Gogh, for example) and some artists want that to be the focus of their art.

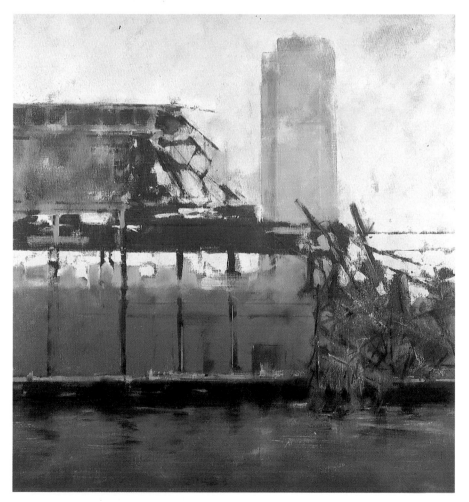

Demonstration:

Pencil Sketch: In a preliminary pencil sketch Richard Rackus works out the placement of major shapes and values.

Step 1: On the toned canvas he sketches the contours of the composition with a quick, gestural stroke.

Step 2: With the same deep red he lays in the basic value structure. Compare this stage of the painting with the preliminary pencil drawing.

Step 3: With the values in place, he adds color. From the very first strokes of color he is beginning to develop the textures of the composition. Notice that he uses a different type of stroke for the leaves in the foreground and the foliage in the distance.

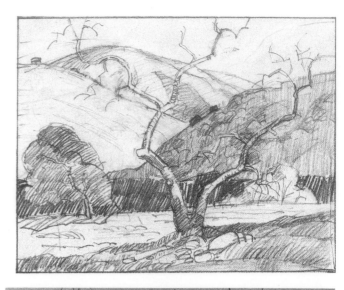

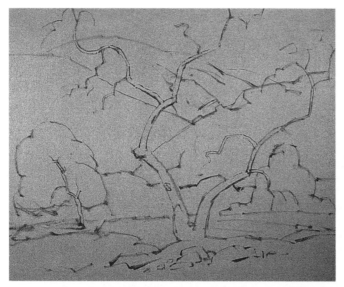

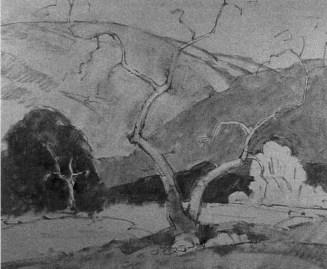

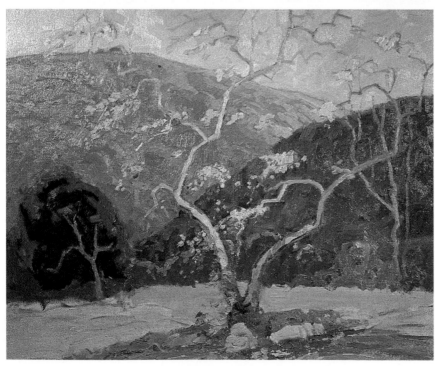

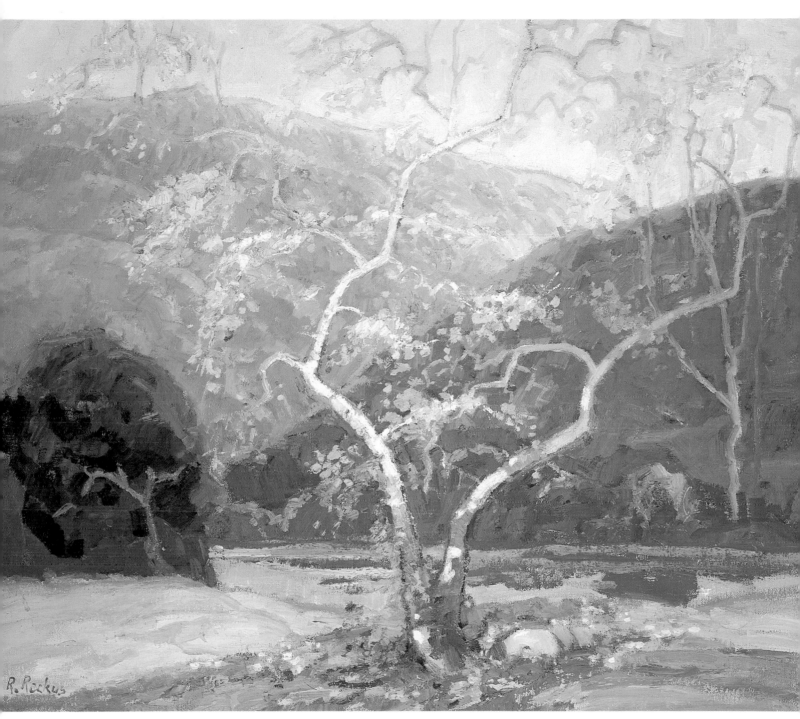

Autumn Leaves
Richard Rackus, 20″ × 24″, Oil
In the completed work you can see the
wonderful variety of paint strokes Rackus
created for this painting. He believes that
every stroke adds to the vitality of the
painting. If a stroke isn't right, he doesn't
try to rework it; he scrapes it off and paints
on a new stroke.

Strokes of Passion

Painting is my identity," says Alberta Cifolelli. "That's how I know myself and how I know the world. As an artist you're looking for truth, trying to find an honest statement of yourself, the intellectual self and the emotional self. The glamorous part is minuscule. You keep working and working, trying to top what you have done. I think it's a totally neurotic activity."

Cifolelli recalls that she was about fourteen when she started making art all the time. In the 1940s when many people were not convinced that girls should even be going to school, Cifolelli somehow convinced her Italian immigrant family that she should attend a boys' high school so that she could study art.

It was Erie Technical High School in Erie, Pennsylvania, with two hundred boys and twenty girls. The school was run by Joseph Plavcan, a serious artist who implanted the same attitude in his students. Students attended studio classes in art all day every day for a week; then on the alternate weeks they had their academic subjects.

Meanwhile, Cifolelli was painting her neighborhood, from downtown to the docks. Her program in school was very traditional, including a lot of drawing, but her paintings were always very direct and very Expressionistic, considered avant garde in Erie in the 1940s. She says that having a sound background in drawing and technique gave her a lot of freedom.

After graduation she won a national scholarship to the Cleveland Institute of Art. She says, "It got pretty tense when I got into my third year and realized I had no way to make a living. After a year as a display artist, I went back to Kent State to get a teaching credential."

She thinks she was fortunate to have a traditional art education. She explains, "When I taught graduate school in the 1970s, my students had trouble doing what they wanted because they didn't know how to draw, they didn't understand space, and they didn't know what to do with the paint. They didn't have the language. I think it's different now; I see some good drawing out there.

"There has been a great contribution by conceptual artists who don't draw and don't care to draw. They have opened many doors. But I just think it's easier if you can draw."

Cifolelli's works are large, richly colored paintings of florals and landscapes that she makes up; they don't exist in nature. The subject is simply a vehicle for the color and stroke. The paintings fit into two groups: "The Way" series and the "Fertile Period" series.

The Way paintings are generally based on a road leading back into a dark space. Cifolelli says, "They're mysterious. I'm not exactly sure myself what they mean." The "Fertile Period" pieces are florals. She says that these are not the sweet, delicate flowers common to floral paintings. "My florals are very sexy paintings," she points out. "Flowers are sexy. Don't forget they're the repro-

ductive organs of plants."

Regardless of the subject, the substance of Cifolelli's work is stroke and color. She says her work has always been very gestural, but it's gotten freer and freer. Because the strokes are bold and the color transparent, the viewer can get a sense of how the artist got to the end result. "There are no secrets— at least it looks that way."

Whether she is painting with oil or acrylic, she always uses sable brushes that are soft enough to capture the fluidity of her strokes. When painting, she likes to work wet so that the edges are soft. With acrylics this means she is constantly spraying the surface with water.

She doesn't decide ahead what colors to use. She starts laying it in and sees what the painting itself dictates. She works with a simple palette—generally two reds, two blues, a green or two, and a couple of yellows. The colors are mixed on the palette, but she works in many layers with very transparent paint. The process of layering gives her colors depth and luminosity. She uses the same layering approach with pastels.

She says, "Color is the thread that runs through my work. That's what painting is about for me. A painting is working when the color does something to me."

Cifolelli loves to work on very large canvases, as big as $80'' \times 90''$. Since she is only 5'1", this makes painting a physical challenge. She says, "I climb up on the ladder, put a stroke down, and then walk back to see how it looks. I have a 'small,

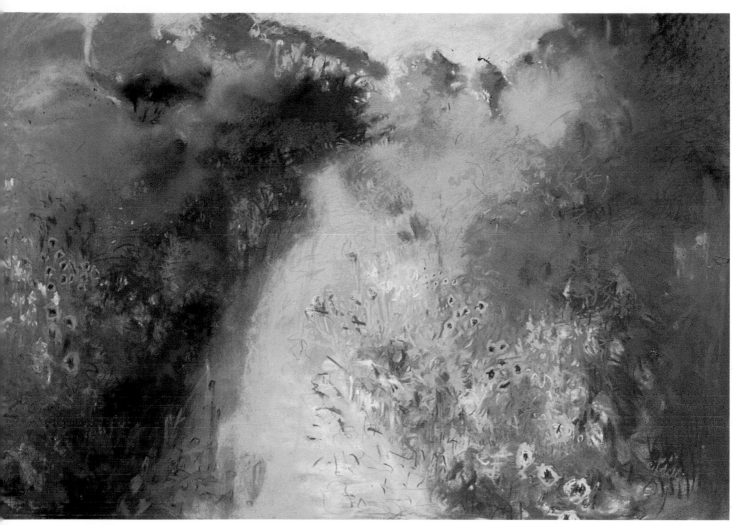

Cleavage, Alberta Cifolelli, 30″ × 40″, Pastel

Cifolelli makes her compositions more dynamic by dividing them into shapes of broad, smooth tones and areas of sharp, frenetic strokes of color. Although none of her paintings are of real places, Cifolelli makes them seem real by combining familiar landscape elements—flowers, trees, paths, water. She varies the type of stroke to be consistent with each element. One of the advantages of pastel is the tremendous variety of textures it will create. Cifolelli uses the full range, from flat, blended areas to tiny, pointillistic strokes.

but ample' studio. To see the painting, I have to walk out of the studio into the dining room.

"I take a long time with these pieces. Even the pastels take a couple of weeks. I'm not finished until I can't think of anything else to change in it."

What does she do when she hits a block? She answers, "I work right through it, but I don't recommend it. You throw out a lot of paintings. If you want to create work that is going to touch and move people, you go through ups and downs. I keep a journal and I have found that there is a rhythm to my creativity. I hit a low just before I go into a time of doing stronger work. Sometimes it lasts a long time. I keep looking and searching and then something starts to click."

Demonstration: A Passion for Imaginative Strokes

Step 1: Alberta Cifolelli has no standard procedure for developing a painting. She begins this piece with a loose contour drawing of the central figure. The flowers are drawn from her imagination.

Step 2: She blocks in shapes of the negative space. Her color choice is intuitive.

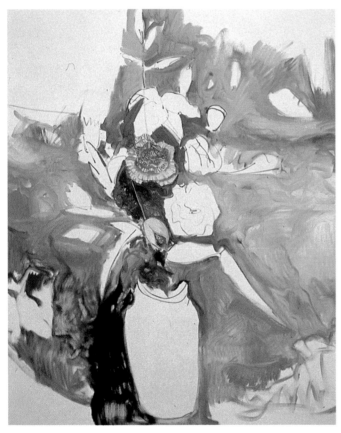

Step 3: She extends the background colors with broad, loose strokes and begins to develop the flowers in the center.

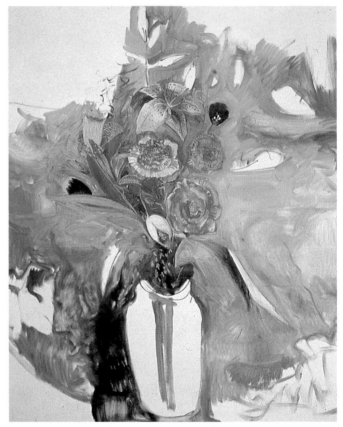

Step 4: As she blocks in the central flowers, she begins to develop texture. Although she adds detail early, she is not "stuck" with anything. She will alter or eliminate any stroke or color for the sake of the total painting.

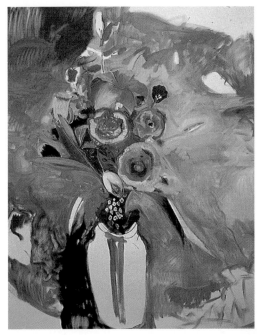
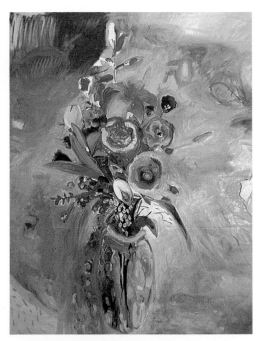

Step 5: She extends the background with stronger colors and continues to define the flowers, bringing more of the red tones from the background down into the blossoms.

Step 6: She finishes blocking in the painting and starts to develop texture throughout the canvas.

Fertile Period #8
Alberta Cifolelli, 64″ × 50″, Oil
For the finished painting she unifies the color by taking down the intensity of the yellows and reds and adding blue throughout the composition. Even this late she will add new shapes; look at the flower at the bottom left of the bouquet.

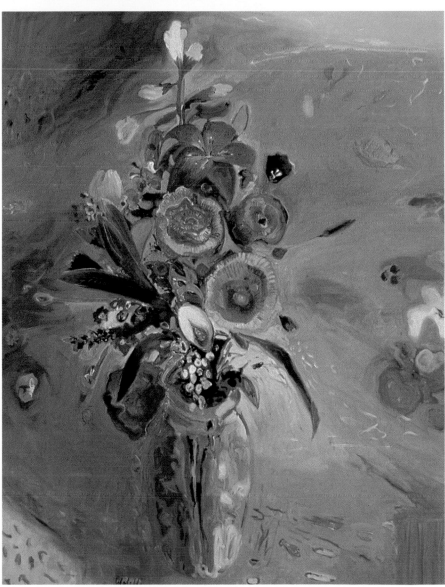

DONNA LEVINSTONE

Keeping It Smooth

The texture that Donna Levinstone creates is soft and mystical, almost a lack of texture. She rubs soft pastel into the paper, creating landscapes that have a dreamlike quality, leaving only a few unblended strokes to indicate a line of trees or reflection of the moon. She says that by keeping the surface simple, it does not detract from the mood of the painting.

"I want people to go inside the painting rather than stay on the surface," she explains. "That's why I don't put in a lot of detail. I want people to have their own experience of the work."

Her paintings are less concerned with showing a particular place than revealing a moment of light and conveying the mood of that moment, like that last ounce of color in the sky before day turns into night.

She says, "I've spent a lot of summers out at Fire Island and the Hamptons where there is a real openness of land, water and sky. I love to be on the beach between four and seven o'clock and watch the changes that are happening in the clouds and the sky. Did you know that the shapes of clouds change from place to place? They have their own unique qualities wherever you go around the world.

"Landscapes are something that I've always been strong about. I've always been in awe of my environment. In the 1980s, landscapes were not the thing to do; they were considered sweet and simple, but I never thought about that. I've lived in New York my whole life, but I've never gotten into the city attitudes. Because I live in a place that's not very calm, I need a place to go where there's harmony and I can escape the hustle and bustle around me. My paintings give me that place."

Her paintings are inspired by places she has visited and by her imagination, but she is less concerned with location than the mood that the painting conveys. She likes to work in series, using similar topographical configurations, but changing the light and color. Sometimes the sky is the most important element and sometimes it is the composition of land. All of the paintings consist of built-up layers of color creating a shimmering, dreamlike image.

Levinstone works from her imagination, memory and photographs. She never tries to reproduce the photographic image; it is merely a jumping-off point. She works on white Stonehenge paper with soft handmade or European pastels. She prefers large chunks of pastel because they cover the space more quickly and give her a greater feeling of freedom; smaller sticks of pastel are better for details.

She blocks in the composition as a few large shapes, usually starting with the top area of sky and clouds. She applies strokes of color. Then with her fingers, palms or whole hands she rubs the color into the paper. (She uses Artguard to protect her hands.) She repeats the process, layering the colors in each area to achieve the shimmering effect that is typical of her work.

Levinstone explains, "For me the process of painting is as important as the finished image. I often change the painting many times before it is complete. I begin by roughly filling in large areas of sky and land. I move through my image creating composition, light source and atmosphere as I go. Blending with my fingers, I 'sculpt' the landscape into simplified forms. Often I add detail only to remove it later, blending back to a simplified state."

She has always enjoyed working in black and white as well as color. She says black and white gives more drama to the landscape. It has more mystery. The intensity is more extreme.

However, when she works in color, she does not use either black or white pastel, only very light or dark colors for her most extreme values. Her lightest highlights will often be a very, very pale yellow. She says the darks must be put in immediately; she can't get intense dark values by placing dark pastel over lighter colors.

Throughout the painting she is more concerned with value than color for delineating shapes and lighting. Color is used primarily to establish mood and to emphasize a focal point. For instance, the horizon line is where a lot of change happens in the lighting, so that's where she puts a lot of color emphasis. She also uses her few unblended strokes for emphasis. The contrast of the untouched stroke against an area of diffused color makes the stroke much more dramatic.

Early Morning Light I, Donna Levinstone, 50″ × 38″, Pastel
Levinstone draws the viewer into this image with the perspective of the receding river and the strong focal point of light at the furthest point of the river. She creates deeper space by painting the distant hills in closely related values and blending the edges of the shapes.

Demonstration: A Passion for the Blended Stroke

Step 1: Donna Levinstone tapes off a one-inch border so that the finished painting will have clean edges. She uses 3M brand's no. 811 tape that won't damage the surface of the paper. She begins the painting by lightly laying in the large masses of the composition.

Step 2: She establishes the color range for the painting, working on white to keep the colors pure. She builds up the colors with layers of pastel that she blends together with her hands and fingers. (She covers her hands first with Artguard to protect them from toxic pigments.)

Step 3: She highlights the sky, emphasizing light from the clouds as it pours down onto the fields below.

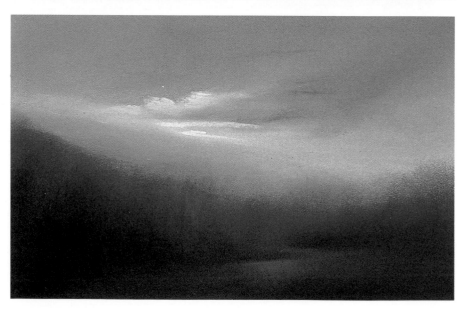

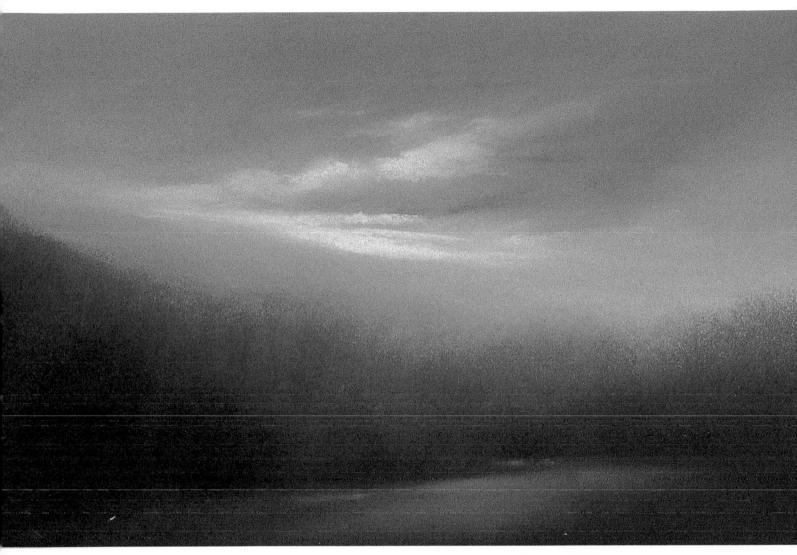

Morning Fields
Donna Levinstone, 8″ × 12″, Pastel
Levinstone completes the painting by taking the light source throughout the image, dotting the trees as well as the land and sky. Her strongest highlights are made with unblended strokes of light color.

Mountain View II
Donna Levinstone, 50″ × 38″, Pastel
Levinstone creates the effect of light on
the foliage by building up many layers of
blended color. The single unblended
stroke of pink light on the water becomes
a focal point because of the dramatic con-
trast.

Early Evening Light
Donna Levinstone, 25″ × 33″, Pastel
Because her strokes of color are blended
into each other, Levinstone relies greatly
on value to delineate shapes and define the
composition. By blending the edges where
lighter and darker shapes meet, she en-
hances the sense of fading daylight.

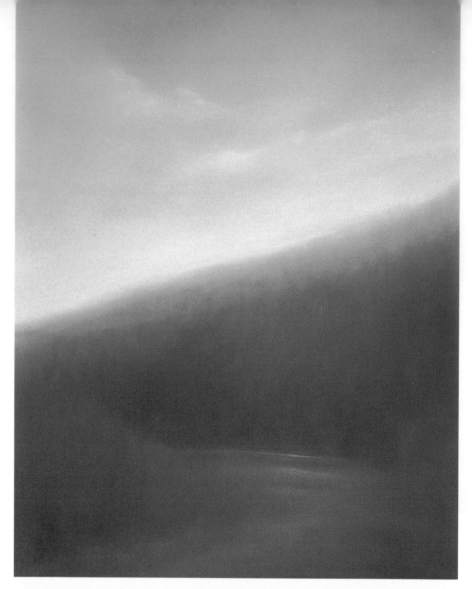

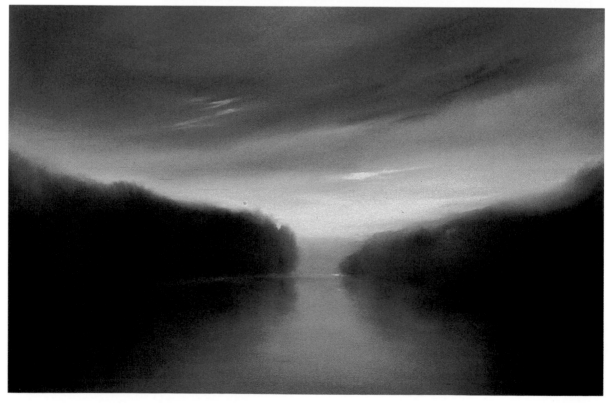

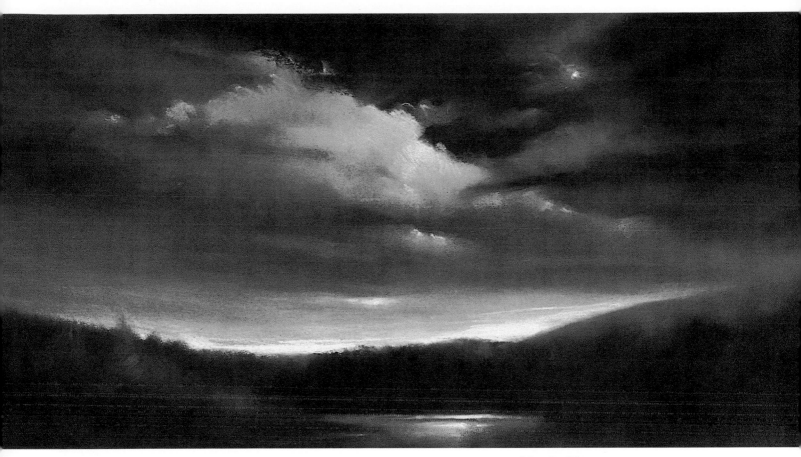

Moonlit Skies
Donna Levinstone, 15″ × 24″, Pastel
Levinstone loves working in black and
white because she says it is the most effec-
tive way to show the dramatic effects of
light on the landscape. She uses the full
value scale, from pure black to pure white.

A Dramatic Gesture

William Vrscak recalls, "My first art class was a total surprise. I expected my teacher to tell me what to do, but he just said, 'Paint what you want.' I told him I don't know what I want to paint. He answered, 'Just make some marks on the paper.'

"That first teacher, Charles Beacham, got me thinking about the abstract quality of marks and I still love looking at them. Marks not only describe subject matter; they have a life of their own. The inherent expressive quality of certain marks and brushstrokes can help evoke the character of the subject.

"The use of many quick strokes in painting may help to express movement and energy in certain subjects. On the other hand, an indiscriminate use of too many brushstrokes can create an overworked image that not only overpowers the life of the subject, but also may indicate the person's incompetence at handling the subject matter. I try to make each stroke count for something. I look for each form's essential structure and try to describe it in as few strokes as possible."

Vrscak says he was always the kid on the block that liked to draw. He had a practical family who believed drawing must be good for something. So he took up sign painting. It wasn't until he was twenty-five that he took his first art class. However, he doesn't resent the sign-painting experience; it taught him discipline that is valuable today and he says he still prefers square, flat brushes.

He attended "a small, but excellent" design school in Pittsburgh called the Ivy School of Art, immediately after which he went to work as a production manager for a large ad agency in Pittsburgh. After sixteen years in the ad business, he left to go on his own as a freelance artist/illustrator.

Vrscak's favorite art activity is drawing on location. He keeps several sketchbooks available in various places at all times, in his car, briefcase, living room, so that he can record what's going on around him. When he worked in downtown Pittsburgh, he spent most lunch hours in one of the squares drawing the figures on park benches.

He says, "I believe good drawing is the foundation of all good painting. A person won't paint anything better than he can draw it. Drawing is not about making pictures with a pen or pencil. It is about seeing the real nature of forms in space and their relationships to one another. There is no better way to learn this than the practice of careful, investigative drawing."

Gesture is a vital element of his drawing as well as his painting. He is not only concerned with the gesture of the subject—the way the forms are moving or relating to one another—but also with the gesture of the lines or marks he is making. The quality or personality of the strokes alone can convey much about the subject.

He works best with quick media—pencils, pens, markers, watercolors. He says, "I can't dwell on things. If I'm not going to finish a painting in two days, I won't do it. In reading I'm the same way; I prefer short stories. The author doesn't have a lot of time. He has to be careful about words, get as much as he can out of every word. That's how I am about my paint strokes."

This love of brevity and simplicity is the foundation of his design sense. He says, "I believe simple statements are the strongest, most effective ones. I try to avoid saying too much in one painting. This does not mean that a painting needs to be void of detail and other information, but it does require the establishment of an order of importance in the work: a primary statement, then secondary information.

"I first try to determine the most important thing to me about the subject. It may be a specific element or focal point in a landscape, or the special effect of light on a still life. It may be the interesting shape or contour created by the model's pose or a strong sense of movement or rhythm created by the alignment of certain visual elements in a landscape, buildings, trees, cars, figures. Once I have established the primary statement, I try to arrange all the elements so as to present that idea in the most direct way.

"Nothing about the subject is sacred to me except this primary statement. I am not against adding, eliminating, moving or changing any element, shape, color, size or value in any way to meet the demands of clarity.

"During the entire painting process I try to stay focused on my original intent. I'm constantly on

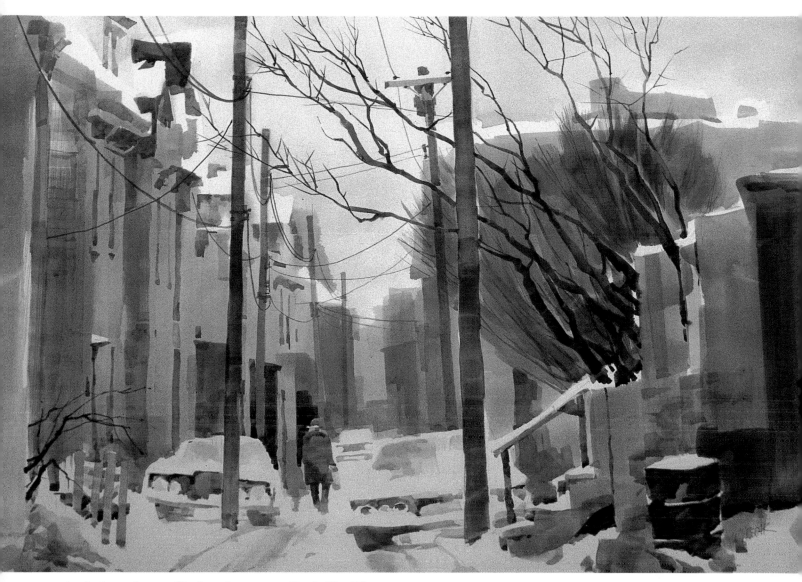

Back Alley Winter, William Vrscak, 22″ × 30″, Watercolor
This is an excellent example of using the shape and direction of the paint strokes to develop the design of the painting. The repetition of narrow, vertical shapes creates a gentle rhythm as it leads the viewer into the distance.

the lookout for conflicting elements that may be stealing attention away from the primary statement. Since watercolor can be a very unpredictable medium, colors may bleed unexpectedly, values may dry lighter or darker than intended. I have to be alert to any occurrences that may affect the unity of design."

Vrscak says that one of the greatest influences on his work has been the study of other artists and he has many favorites: "Jan Vermeer for his marvelous technique; van Gogh for his intensity; Toulouse-Lautrec for his wit; Egon Schiele for his outrageousness; Robert Henri for his 'art spirit'; Franz Kline for his energy; and Richard Diebenkorn for his surfaces."

Demonstration: A Passion for Simplicity

Step 1: William Vrscak begins with a contour drawing in which the proportions must be correct. He says he won't paint the portrait any better than he draws it.

Step 2: He lays in very wet washes over most of the surface, not concerned at this stage about colors running into each other. He establishes the dark value of the blouse against which he will key the rest of the painting.

Step 3: After the paper has dried, he begins to place the shadows in the hair, face and chair. He is much more precise with his strokes now because the shapes of the shadows will define the form of the figure.

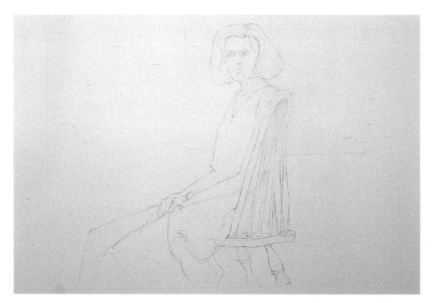

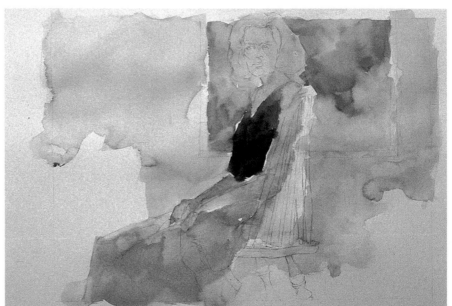

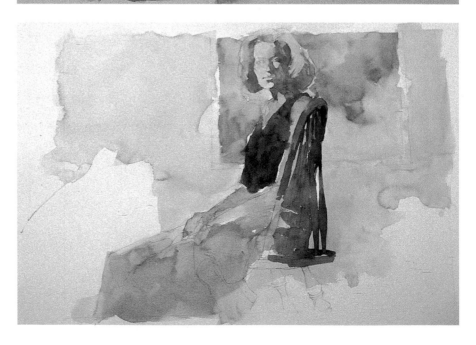

Detail: When working on dry paper, each watercolor stroke has a definite shape. Although he says he loves the marks of paint on paper, he uses as few brushstrokes as possible in order to keep the painting from looking overworked.

Marlene
William Vrscak, 22″ × 30″, Watercolor
Once all the large shapes are put in, finishing the painting is simply a matter of tightening up the details. Adding the calligraphic pattern to the skirt unifies it as one shape. All the strokes look quick and spontaneous because Vrscak places them carefully. He knows that if he goes back and reworks an area it will lose its freshness.

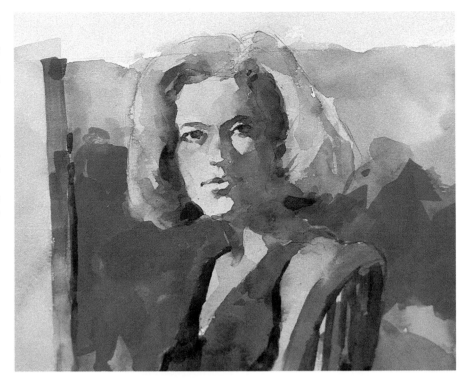

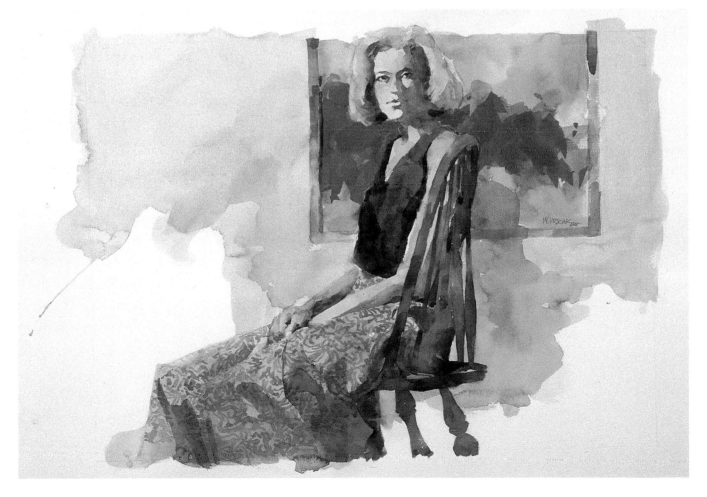

Shopping Break
William Vrscak, Sketchbook drawing with
felt-tip pen

Shopping Break
William Vrscak, 15″ × 22″, Watercolor

Vrscak keeps a sketchbook handy at all
times to capture interesting scenes and
characters. He draws with a fast, fluid line
to capture the contours as well as the ges-
ture of the figure or figures. In his painting
of the same subject he tries to retain the
attitude and relationship of the figures.

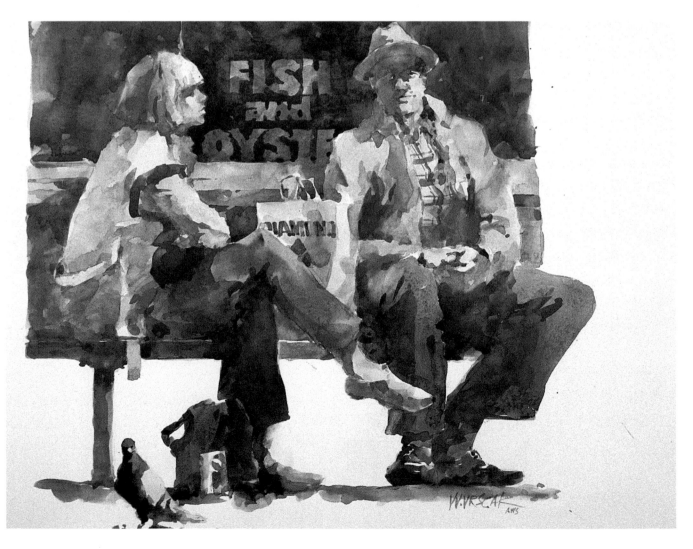

Vrscak often works from photos, but only as a resource. He feels free to move or change any of the elements in the scene. Then, he does a small sketch to work out the composition. He designs shapes and values, eliminating unnecessary detail.

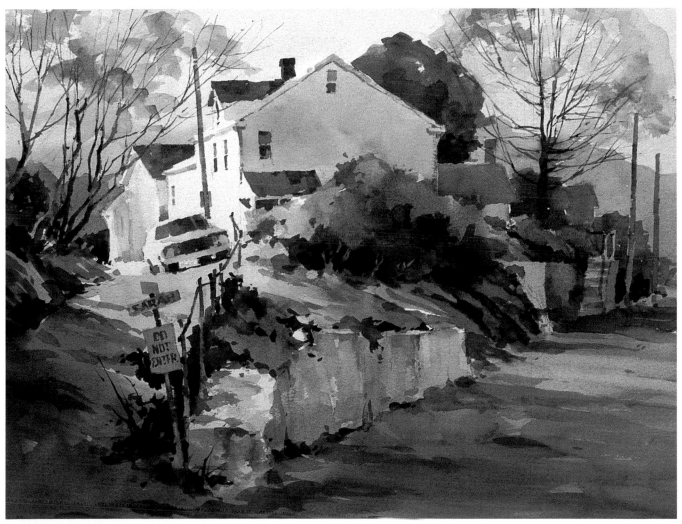

West Homestead, William Vrscak, 18″ × 24″, Watercolor
Vrscak refers back to both the photo and pencil sketch while he is painting the final watercolor. Since he has already worked out many of the problems, he is able to paint most of the image with just a few broad strokes of color.

PAINT FOR PAINT'S SAKE

Some artists are obsessed with a particular subject; other artists are passionate about color or design or stroke; and others just love the process of putting down the paint.

Every medium has its own challenges and opportunities for discovery. No matter how many artists have painted with oil, acrylic, pastel or watercolor before, there is always a fresh way to approach the medium, an individual way for the painter to express his or her own vision with that same medium.

For some artists the excitement comes from looking for the new and experimental. For others the thrill is in trying to understand and re-create what the masters did centuries before. There is no end to the possible ways of studying media and techniques.

Probably the most commonly used medium in America today is watercolor. It's fast, portable and relatively inexpensive. Over the last several years we have seen an amazing proliferation of watercolor classes, workshops and books, all offering new and exciting techniques for watermedia.

This phenomenon is one of the delights of watercolorists, but it's also one of the dangers. It is possible to get so involved with the techniques that you forget what or why you are painting.

Says William Vrscak, "One of the problems with watercolor is that it is fraught with techniques. Students just want to learn the technique. I've done all the techniques, but now I'm just a painter."

Whether you study painting materials because you are fascinated by the materials themselves or just because you need to know how to create a particular image, learning to use your materials well and efficiently offers great rewards.

The immediate benefit is in the freedom to express your vision without technical obstacles. Make a friend of your medium and it will serve you well; fight with it and it will be your worst enemy. You don't have to take an academic approach to learning technique, studying chemical formulas and manufacturing systems. Often, just using the materials over and over, and taking the time to observe how they act, will give you all the knowledge you need in order to be a competent painter.

The other benefit of studying your materials, and this does require a slightly more rigorous approach, is that when you know your materials well, you can produce work that will be permanent. I have been surprised at how impermanent many materials and techniques are.

David Hunt suggests getting technical sheets from the manufac-

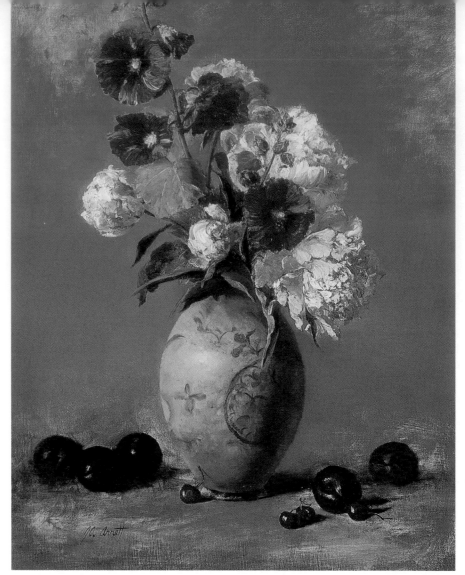

Hollyhocks and Peonies, Joe Anna Arnett, 24″ × 18″, Oil
In this painting you can see the wide variety of brushwork available with oils. The background is painted with thin, loose strokes. The flowers show thick impasto strokes.

Birds Near Little Sur, Gil Dellinger, 30″ × 42″, Pastel
Dellinger prefers to leave distinct strokes of color on his paintings, creating a vibrant surface texture. The strokes are crisper in the foreground and become softer in the distance to create a sense of spatial depth.

River's Edge, Donna Levinstone, 24″ × 36″, Pastel
Levinstone's approach to pastel is to blend all but a few strokes
of highlight color. The result is a smooth, shimmering surface.

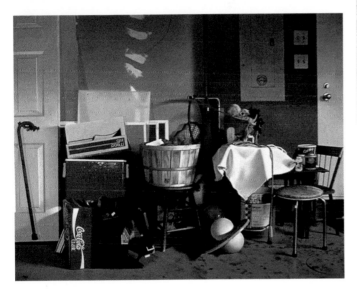

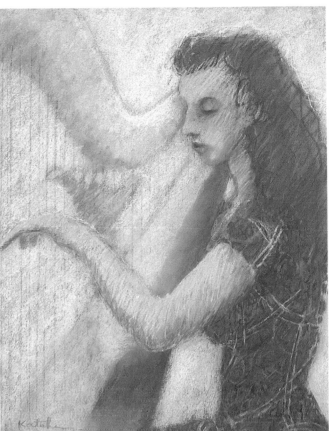

Playing Debussy, Carole Katchen, 25″ × 19″, Pastel
I used unblended linear strokes in the figure to add more visual
excitement to what is a soft and graceful pose. The background
and harp demand less attention because the color is blended to a
smooth finish.

Family, David Hunt, 30″ × 36″, Oil
This piece shows the precision possible with oil. Hunt precisely
draws the image on the canvas and then slowly builds up the color
by glazing and scumbling.

turers of the products you are using. He has found that some of them are difficult to track down, but they all do exist. You can get the addresses of manufacturers from your local art supply store.

Hunt warns, "If you read the technical data, you'll see that most of the watercolors, even the best brands, are made with fugitive colors. A fugitive color either fades from ultraviolet light or changes from chemical reactions. For instance, anything that contains zinc can turn black when exposed to sulphur dioxide as in a smoky environment. Oil protects it somewhat, but water-based paints are very vulnera-

ble. Flake white is much more permanent."

Colors in paint or chalk can fade or change, varnish can turn yellow or dark, paper can turn brown and disintegrate, and as Hunt warns, just using the most expensive materials does not guarantee their permanence. Besides getting the manufacturer's reports, you can learn more about the characteristics of specific materials by discussing them with knowledgeable clerks at art supply stores, reading books and articles, and doing simple tests in your studio.

For instance, to check if a color is going to fade or a paper turn

yellow, you can put the painted color or piece of paper in a sunny window. Cover half of what you're testing with thick paper to protect it from the sun. Then go back and look at the two samples, the covered and the uncovered, periodically to see what effect the ultraviolet light is having.

Also there are simple kits to determine if your paper has any acid content. Unless the paper is acid-free, it will darken and disintegrate in time.

Even if the materials themselves are sound, questionable techniques can damage or destroy your artwork. I know an artist who painted big,

abstract canvases in a combination of oil paint, house paint, crayons, and whatever else was handy. He was quite embarrassed when, after just a few years, a painting he had sold for $10,000 began to fall apart. The paint was literally falling off the canvas.

A few simple rules: Never paint water-based media over oil-based media. Never paint thin layers of paint over thick layers that might not yet be completely dry. Don't use glues or tapes with any acid content. Don't mount paper works on backing or mats that are not acid-free.

Another important consideration is the toxicity of the materials. Many chemicals used in art supplies are poisonous to touch or breathe.

Even such an apparently innocuous thing as dust can be dangerous to your health if inhaled regularly.

There are excellent books available on materials and painting methods that are great to have around as a handy reference. When you are knowledgeable about the materials, you can paint with greater confidence and freedom.

I love pastels. I love the way I can put down a stroke and either leave it there as a line or blend it into a soft tone. I love being able to work and rework and rework my pastel paintings, knowing that no matter what I do, I will never ruin the painting. If worst comes to worst, I can brush the color off, rub it in, or spray it with fixative so that I have a workable but toned surface

to continue on. This freedom and confidence comes from twenty-five years of working and playing with the medium.

Reading this book, you have encountered artists who have the same love for watercolor, oil or acrylic.

How do you find the media and techniques that are most satisfying for you? Simply by experiencing what is available. It takes a particular attitude, however. You cannot be worried about failing or what people will say if they find out you don't know what you are doing. You have to be a perpetual student, admitting that you don't know everything and grateful that you don't. How boring to be an artist and be able to predict how every stroke is going to look!

Pumpkin, Henry Casselli, 29″ × 21″, Watercolor
Casselli gets his rich, dark values by using a brush loaded with dark paint. Many of the whites are sanded or scratched into the paper after the paint has dried.

Old Glory, Arlene Cornell, 24″ × 18″, Watercolor
Watercolor has a mind of its own, so even in areas with sharp architectural details there are uncontrolled variations of color.

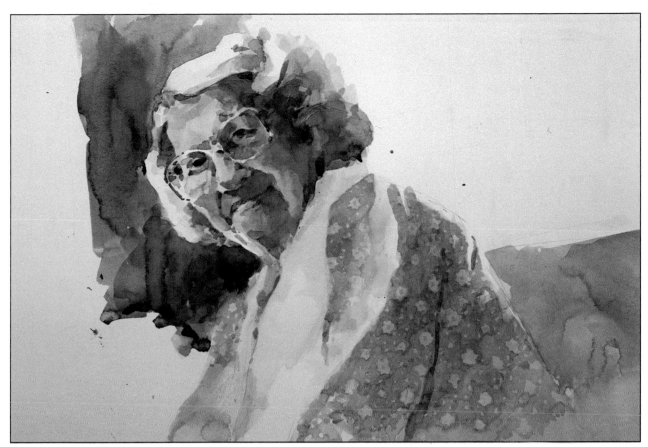

Gram
William Vrscak, 15″ × 22″, Watercolor
Vrscak paints with a loose, flowing style of watercolor. He uses the shapes of the strokes to define the form of the figure.

Getting More Support

Many artists do not realize how the support or surface on which they are painting affects the results. The same paint will have a much different feeling on stretched canvas than on gessoed panels. You cannot really know your paints until you also know what they are being applied to. Take the time to experiment with a variety of supports.

Here are a variety of unusual surfaces Kay Polk uses for her pastel paintings:

- Masonite panels primed with marble dust or ground pumice in matte medium with some acrylic color for tone.
- Le Carte paper, which is ground vegetable fiber in bristol board distributed by Sennelier. It comes in a variety of colors and has as much tooth as sandpaper without being as rough on fingers or pastels.
- Unprimed, raw linen attached to untempered Masonite with rabbitskin glue. She uses a brayer to roll out air bubbles and seals the surface of the linen with two more coats of rabbitskin glue.

Polk also uses a wide variety of techniques and materials for applying pastel and pressing it into the surface, including rags, stumps, paper towels, fingers and fixative. The fixative wets the pastel enough to paint with stumps. She warns: Keep the studio well ventilated whenever you are using fixative.

The Poetry of Paint

Poetry in the heart, with well-developed skills, is all it takes to become a great painter," according to Philip Salvato, accomplished painter of both landscapes and portraits. Although he speaks more about poetry and emotion, he is equally dedicated to mastering the technical skills of an artist, going so far as to mix his own paints and medium.

He says, "The arts were in my family. My uncle and his father were musicians. My cousin was an artist. I spent as much time as possible in my cousin's shop watching him paint signs and billboards."

Salvato went to the Art Institute of Pittsburgh and then served an apprenticeship in a commercial art studio. He recalls that those early years as a commercial artist were a time of great frustration. "I was trying to take care of my family and pay the bills and please the client and develop as an artist. I wanted to do something else. A big change occurred when I met the portrait artist Abbott Ross. I looked into his studio one day and saw him painting a woman in a beautiful gown. It touched something deep in me."

The transition to fine artist was not easy with the gas company and the bank calling about overdue bills, but Salvato is not a man to give up. He says, "The key to it all is to keep painting and keep painting and keep painting. The only thing that stops you from painting is to stop painting."

For Salvato the foundation of any image is light. He talks about being one-on-one with the light, not just seeing it, but experiencing it. He says, "Landscape painting is what really trained me to see the subtle nuances of light—the lightness, the darkness, the middle tones, and the colors within all that. I love being outside with nature, watching light change during the day. I look at light and forget the names of things, seeing everything simply as objects in light."

He says that charcoal drawing is an excellent way to learn to show value. It goes on fast. You can move it around the paper, rub it in or lift it off.

He often prepares his own surface so that the charcoal will move around more easily. He starts with rag board and then brushes that with rabbitskin glue containing a small amount of color. When the glue dries, it tightens the surface like a drum. Sometimes he adds a bit of marble dust to the sizing, which will give the surface some tooth to hold the pigment in place.

Salvato says, "The success of a portrait depends on being able to see the lights and darks in the face. It takes tremendous focus and concentration, like continually walking a razor's edge. You have to be such a good draftsman that most of your work is unseen. From a distance the painting must have elegance, depth, and a wonderful sense of beauty and still appear simply done. The challenge is to put a sense of idealism and hope into the subject and still show the experience of life."

Landscape painting also expanded his sense of color. He recalls walking from inside his fairly dark studio out into nature with its abundance of color and nuances of color. There were times when he went outdoors to paint with seventy-two colors premixed on his palette because he didn't want to take the time to mix the colors out there. Eventually he went back to a more simple palette, sometimes a combination of basic yellow, red and blue.

"Color is relative," he says. "If I see a blue sky, I'll put down a basic blue, but I know that the sky also contains red and yellow, so I look for where those are. I see each shape as a basic color mass and then look for the other colors that are within it. The trick is to make all of that look simple."

Salvato mixes much of his own oil paint and medium, which he admits can be dangerous if you are not careful. At a time when he was experimenting with mixing oil-painting mediums, he noticed he was very depressed and wondered what had happened to him. Then he realized that he was cooking lead into oil and might have a minor case of lead poisoning. He still cooks lead into oil, but takes better precautions.

The advantage of mixing his own materials is that he has more control over them. He says, "I can make a short (buttery) paint or make it longer by adding more stand oil. I can make it as opaque or transparent as I like. I can work in different values. It becomes more personal."

Salvato believes that part of his job as an artist is to make a contribution to his community. He had worked in a studio with other artists

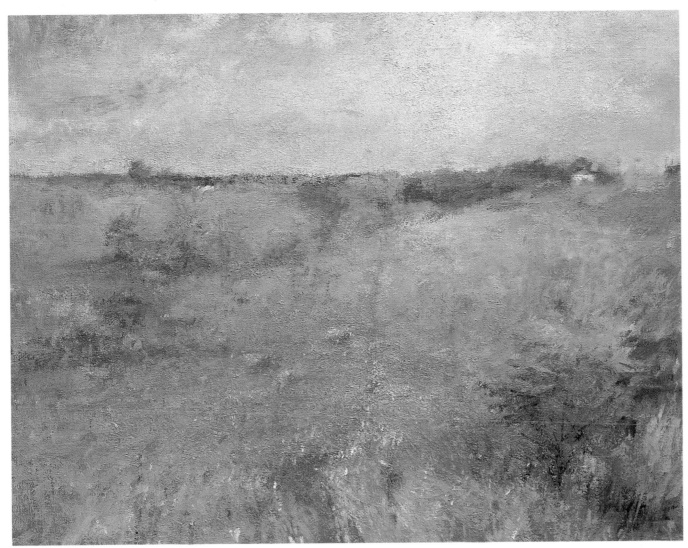

at Snuggery Farm for years. Then the farm was sold and he had to find a new place to work. After six months of struggling with the small space and distractions of painting at home, he found a three-story building that might work.

He says, "The building needed a lot of work and everything looked dark and overwhelming. I had very little money and was living from painting to painting. I remember being parked down the street from the building at midnight trying to make a decision. I borrowed money and did whatever needed to be done, cleaning, painting, sanding floors, and dealing with difficult tenants. A painting sold just in time to meet the immediate expenses.

"Now the studio has become a place in town where people enjoy coming for special events — lectures on philosophy, poetry readings, art historians giving lectures, grand openings. The whole community is involved. In the summer other artists and I paint on the streets. The community loves it. At first they wondered what descended on them. Now they stop and talk; cars honk to say, 'Hi!'

"I personally feel that, as artists, it is our job to inspire humanity. We do this by giving homage and living in the splendor of life. If I could leave something behind, it would be a statement about the beauty of the world."

Field Near Settler's Park
Philip Salvato, 26″ × 32″, Oil
This location painting required several trips back to the same spot before the artist was able to capture the feeling of warm serenity he sought. Notice the rich use of scumbling. Texture is achieved by dragging a brush lightly over already-dry strokes of color; the new color is left only on the tips of the previous surface.

Demonstration: A Passion for Poetry

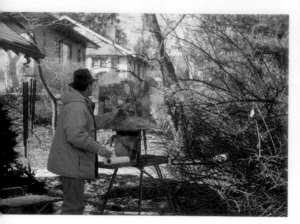

Here Philip Salvato paints on location. By comparing the scene around him and the colorful painting he is executing from that scene, you can see how much freedom he takes in using color to express his impression of the subject. He wants each painting to be a poetic view of the scene.

In this 9″ × 12″ oil sketch (above right), Salvato works out the basic composition and colors.

Step 1: His underpainting is done in a warm orange that will give vitality to the cooler colors he will paint over it.

Step 2: Using broad, loose strokes he follows the plan of the preliminary sketch.

Step 3: He blocks in the whole painting using loose strokes that suggest rather than define the subject.

View From My Deck
Philip Salvato, 20″ × 30″, Oil
Salvato refines color and shape until the image comes into focus. His use of oils in landscape painting is characterized by building up many layers of colors, scumbling the last thick layers of paint to create a rich surface color.

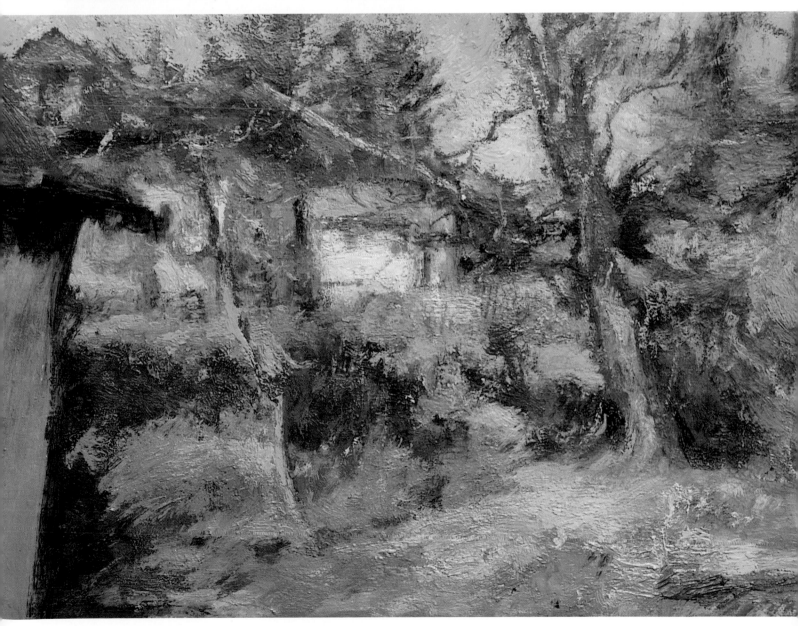

Mind Over Machine

Around 1984 I was a water-colorist and trying to push the medium as much as I could," says Norma Auer Adams. "I was working wet-in-wet, striving for a dense, velvety, blended color, not broken up with a lot of brush-strokes. But with watercolor, you couldn't go back over it and I didn't like the texture of the paper showing through. I thought, What if I could just blow the paint onto paper?"

So she bought an airbrush. She tried spraying watercolor and the first layer was great, but she found she still couldn't go over it because the first layer dissolved under additional moisture. Next she tried acrylics diluted with medium. The paint was more stable, but the machine clogged. She tried six different machines, finally ending up with diluted acrylic and a large turbo jet compressor intended for spraying cars.

She says, "Even from the beginning I found I have a richer color, something that breathes. It has a wonderful surface, an elegant surface like velvet. You just want to stroke it."

At first Adams was an abstract artist, concerned only with shape, color and space, but she wanted to incorporate keener observation into her art. So she began to look for those same elements of design in the real world. She says, "I was fortunate to discover watercolorist Christopher Shank as a teacher. It's so important to have someone who authenticates what you do and motivates you to go on."

Adams is totally committed to her medium of airbrush, but says she wouldn't recommend it to anyone who doesn't have a lot of patience and a mechanical bent. "I have to take breaks to keep flushing water through them as I go and I soak them every night in cleaning solution. You can't be cavalier about your materials."

With airbrush each of her large paintings is a long process, taking from one to eight months. Not only does she do extensive planning, but she must be deliberate and careful while she is painting. She works in layers of color, masking those areas that won't be painted. It can take a day and a half to cut a "Frisk" that will take only twenty minutes to paint.

She says, "In order to prevent what I call the 'cookie cutter' effect that often shows up in airbrush work, especially where a resist (i.e., the Frisk Film) is used, I will frequently take a small watercolor brush and blend the edges with paint dipped from one of the pre-mixed containers. If I do this all along as I paint, I'm able to create an image which coexists with the fore- and background, rather than looking as if it's crisply cut out and separate from it. I also do a lot of freehand airbrushing, which softens edges and blends areas as I work on them."

Her paintings begin with a long walk, a camera, a macro lens and slow exposure film to gather information she wants for her paintings. She says, "After taking many photographs of subjects I feel might make good paintings, I go through the photos and discard all but those very few that I feel can be translated successfully into what I want to paint. As I choose the image, I make sure it's one I'm drawn to with considerable intensity. The way I paint is a long and sometimes tedious process, so I have to be sure ahead of time that I'm so deeply drawn to the image, I'll want to live with it for months."

Especially when working on paintings that take such a large commitment of time and energy, she says that inevitably she goes through a period of despair in every piece. She advises, "You just have to fight your way through. At first I tried starting over, but I found I would paint myself back to the same place. I would get depressed, thinking not only is this a bad painting, but I'm a bad painter.

"I learned just to keep trying new things until I find out why it isn't working. Eventually I do resolve it and usually the ones I have fought the hardest are the richest when I have finished. I feel a great bond with each of the pieces I complete, but what I've learned is the most important thing I keep from each painting. In a way, the finished images become like postcards of a journey I've taken, the final embodiment of the experiences of the trip."

Bird in the Branches, Norma Auer Adams, 48″ × 36″, Acrylic
To complete such an intricate composition as this, Adams must have tremendous patience in planning and masking off the many pieces of positive and negative space.

Before she begins, Norma Auer Adams mixes enough paint to complete the painting. She buys acrylics in jars and then mixes and thins the colors with equal parts of gloss acrylic medium and water. She strains each color through a piece of silkscreen cloth into a pint jar. She stores the paint in a refrigerator. The finished colors in the paintings will result from many thin, sprayed layers of these colors.

Step 1: Adams begins by drawing the subject onto stretched and gessoed canvas. This is a fragment of the drawing.

Step 2: She masks off the large flower shape with frisket film, then sprays the background.

Step 3: She removes the frisket film, leaving a white shape in the center. She starts painting the actual flower with the focal point, the intricate section in the middle. She masks off the rest of the flower and sprays each little segment of the stamen in sequence.

Step 4: The next sections to paint are the pink areas behind the large white flower. Even though they are on opposite sides of the flower, she paints them at the same time because they are the same color.

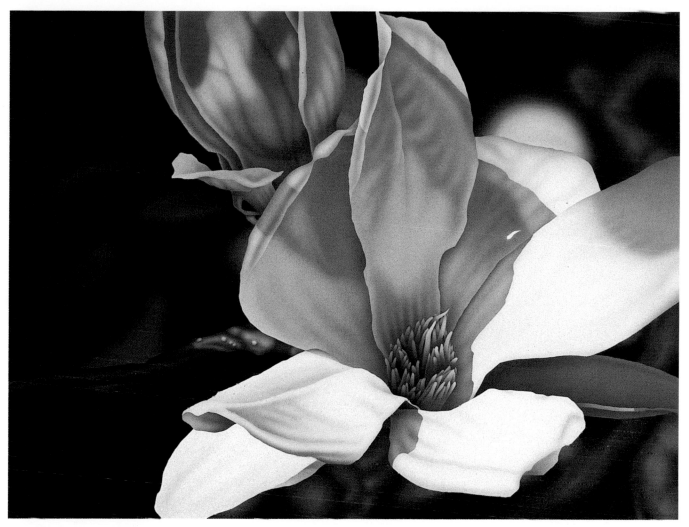

Magnolias, Red and White, Norma Auer Adams, 36″ × 48″, Acrylic
Finally Adams paints the large white flower. She uses the same system of masking and spraying to build up the shadow areas. She masks off completed areas of the painting to protect them from later layers of paint.

Details: In the details you can see the smooth surface and crisp edges Adams achieves with her airbrush technique. Notice the subtle color changes of stems and leaves behind the flower.

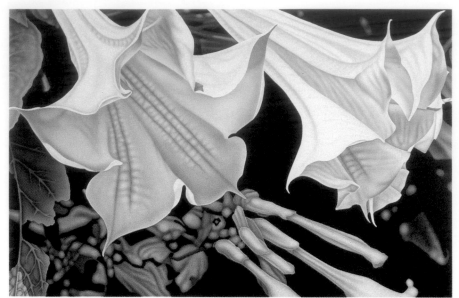

Trumpet Flowers
Norma Auer Adams, 30″ × 40″, Acrylic
Adams uses the dramatic power of the white canvas by masking the white sections and painting intense colors and dark values around them. At times she loses the whiteness while she is painting the shadows and details. She can bring back the crispness by spraying with a layer of white acrylic.

Wisteria Suite I
Norma Auer Adams, 29″ × 21″, Acrylic
When Adams paints a cluster of flowers like this, she looks at the whole group of flowers as one large shape to be arranged within the negative space.

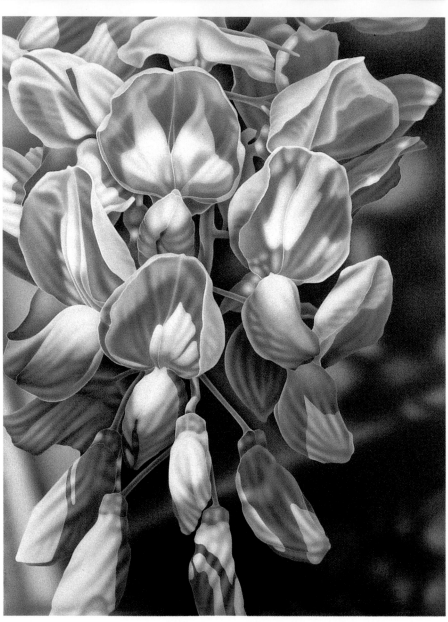

Conclusion

Southwest Series, Norma Auer Adams, 48″ × 72″, Acrylic

Writing this book, I have wondered if it's possible for an artist to paint without passion. Can you paint day after day, creating images from nothing, like magic, and not be touched in a deeply emotional way? I don't think so.

What we are passionate about and the ways that we express that passion differ from artist to artist. David Hunt stands at an easel painting the same image for 250 hours. Alberta Cifolelli climbs up and down a ladder for every stroke of her painting. Phil Salvato cooks lead into oil, and Gil Dellinger sits on a hillside watching the light change. It is all an expression of passion.

We don't choose the passion. It chooses us. From the time we are young, we are drawn to beauty, to seeing and expressing beauty in a tangible way. It is a gift and an obligation, for which we must each pay a price. Every artist makes sacrifices—financial security, human companionship, physical comfort.

Artists live in a constant state of tension: Will the next painting be as good as the last? Will it please my audience, will it please me, will it please my muse, that force that is always demanding more skill, more sensitivity, more brilliance?

But we also live in a state of grace. Our world is an unending source of inspiration, intriguing shapes, subtle nuances of color and ever-changing light that turns the most mundane objects into glittering surprises.

Kay Polk sent me a wonderful statement about what it is to be an artist. It is from a catalog to a retrospective exhibit of Emily Guthrie Smith written by Donald L. Weisman, Professor Emeritus, University of Texas:

"Sometimes even as children, we were stopped by some configuration of colors, shapes and textures—no matter the nameable object they described—stopped in our tracks and stared in silent wonder, awe, admiration or bewilderment. And sometimes some of us had the feeling, even way back then, that this kind of experience was asking something of us—as if we were being solicited for a response appropriate to the force that stopped us. And some of us even came to believe that a debt of gratitude is owed for the gift of vision, the capacity to experience the color and space of the visual world."

Kay Polk says, "I can hate art so much. There have been several times when I've painted horns or mustaches on an angelic little child, angry at the constraints money or clients put on me or frustrated that my mechanical skills aren't great enough to capture my vision. But I continue to paint because there's something in me that needs to be expressed. Art has given me more than I ever gave to it."

Index

Improve your skills, learn a new technique, with these additional books from North Light

Watercolor

Alwyn Crawshaw: A Brush With Art, by Alwyn Crawshaw $19.95

Basic Watercolor Techniques, edited by Greg Albert & Rachel Wolf $16.95 (paper)

Buildings in Watercolor, by Richard S. Taylor $24.95 (paper)

The Complete Watercolor Book, by Wendon Blake $29.95

Fill Your Watercolors with Light and Color, by Roland Roycraft $28.95

How to Make Watercolor Work for You, by Frank Nofer $27.95

Learn Watercolor the Edgar Whitney Way, by Ron Ranson $27.95

The New Spirit of Watercolor, by Mike Ward $21.95 (paper)

Painting Buildings in Watercolor, by Ranulph Bye $27.95

Painting Nature's Details in Watercolor, by Cathy Johnson $22.95 (paper)

Painting Nature's Peaceful Places, by Robert Reynolds with Patrick Seslar $27.95

Painting Outdoor Scenes in Watercolor, by Richard K. Kaiser $27.95

Painting Watercolor Florals That Glow, by Jan Kunz $27.95

Painting Watercolor Portraits That Glow, by Jan Kunz $27.95

Painting Your Vision in Watercolor, by Robert A. Wade $27.95

Ron Ranson's Painting School: Watercolors, by Ron Ranson $19.95 (paper)

Splash 2: Watercolor Breakthroughs, edited by Greg Albert & Rachel Wolf $29.95

Tony Couch Watercolor Techniques, by Tony Couch $14.95 (paper)

The Watercolor Fix-It Book, by Tony van Hasselt and Judi Wagner $27.95

The Watercolorist's Complete Guide to Color, by Tom Hill $27.95

Watercolor Painter's Solution Book, by Angela Gair $19.95 (paper)

Watercolor Painter's Pocket Palette, edited by Moira Clinch $16.95

Watercolor: Painting Smart!, by Al Stine $21.95 (paper)

Watercolor Tricks & Techniques, by Cathy Johnson $21.95 (paper)

Watercolor: You Can Do It!, by Tony Couch $29.95

Webb on Watercolor, by Frank Webb $22.95

The Wilcox Guide to the Best Watercolor Paints, by Michael Wilcox $24.95 (paper)

Zoltan Szabo Watercolor Techniques, by Zoltan Szabo $16.95

Other Mediums

Alwyn Crawshaw Paints Oils, by Alwyn Crawshaw $19.95

Basic Drawing Techniques, edited by Greg Albert & Rachel Wolf $16.95 (paper)

Basic Landscape Techniques, edited by Greg Albert & Rachel Wolf $16.95

Basic Oil Painting Techniques, edited by Greg Albert & Rachel Wolf $16.95 (paper)

Basic Portrait Techniques, edited by Rachel Wolf $16.95

Blue and Yellow Don't Make Green, by Michael Wilcox $24.95

Bringing Textures to Life, by Joseph Sheppard $21.95 (paper)

Capturing Light & Color with Pastel, by Doug Dawson $27.95

The Complete Acrylic Painting Book, by Wendon Blake $29.95

Tony Couch's Keys to Successful Painting, by Tony Couch $27.95

The Creative Artist, by Nita Leland $22.95 (paper)

Creative Painting with Pastel, by Carole Katchen $27.95

Dramatize Your Paintings With Tonal Value, by Carole Katchen $27.95

Drawing: You Can Do It, by Greg Albert $24.95

Energize Your Paintings With Color, by Lewis B. Lehrman $27.95

Enliven Your Paintings With Light, by Phil Metzger $27.95

Exploring Color, by Nita Leland $24.95 (paper)

Foster Caddell's Keys to Successful Landscape Painting, $27.95

How to Paint Living Portraits, by Roberta Carter Clark $28.95

Keys to Drawing, by Bert Dodson $21.95 (paper)

Light: How to See It, How to Paint It, by Lucy Willis $19.95 (paper)

Oil Painter's Pocket Palette, by Rosalind Cuthbert $16.95

Oil Painting: Develop Your Natural Ability, by Charles Sovek $29.95

Oil Painting: A Direct Approach, by Joyce Pike $22.95 (paper)

Oil Painting Step by Step, by Ted Smuskiewicz $29.95

Painting Flowers with Joyce Pike, by Joyce Pike $27.95

Painting Landscapes in Oils, by Mary Anna Goetz $27.95

Painting More Than the Eye Can See, by Robert Wade $29.95

Painting the Beauty of Flowers with Oils, by Pat Moran $27.95

Painting the Effects of Weather, by Patricia Seligman $27.95

Painting Vibrant Children's Portraits, by Roberta Carter Clark $28.95

Painting with Acrylics, by Jenny Rodwell $19.95 (paper)

Pastel Interpretations, by Madlyn-Ann C. Woolwich $28.95

Pastel Painter's Pocket Palette, by Rosalind Cuthbert $16.95

Pastel Painting Techniques, by Guy Roddon $19.95 (paper)

Perspective Without Pain, by Phil Metzger $19.95

The Pleasures of Painting Outdoors with John Stobart, $19.95 (paper)

Sketching Your Favorite Subjects in Pen and Ink, by Claudia Nice $22.95

Strengthen Your Paintings With Dynamic Composition, by Frank Webb $27.95

Timeless Techniques for Better Oil Paintings, by Tom Browning $27.95

Tonal Values: How to See Them, How to Paint Them, by Angela Gair $19.95 (paper)

Welcome To My Studio: Adventures in Oil Painting with Helen Van Wyk, $24.95